The Book of Thel

THE BOOK

WILLIAM BLAKE

OF THEL

A Facsimile and a Critical Text

Edited by Nancy Bogen

BROWN UNIVERSITY PRESS · Providence

THE NEW YORK PUBLIC LIBRARY · New York

International Standard Book Number: 0–87057–127–3

Library of Congress Catalog Card Number: 74-155857

Brown University Press, Providence, Rhode Island 02912

Published 1971

Set in Monotype Van Dijck by Mackenzie & Harris, Inc.

Printed in the United States of America

Text printed by Connecticut Printers, Inc.

Illustrations printed by Meriden Gravure Company, Inc.

On Mohawk Superfine Text

Bound by Stanhope Bindery

Designed by Richard Hendel

IN MEMORY OF
MINNA ZWAIFLER

Contents

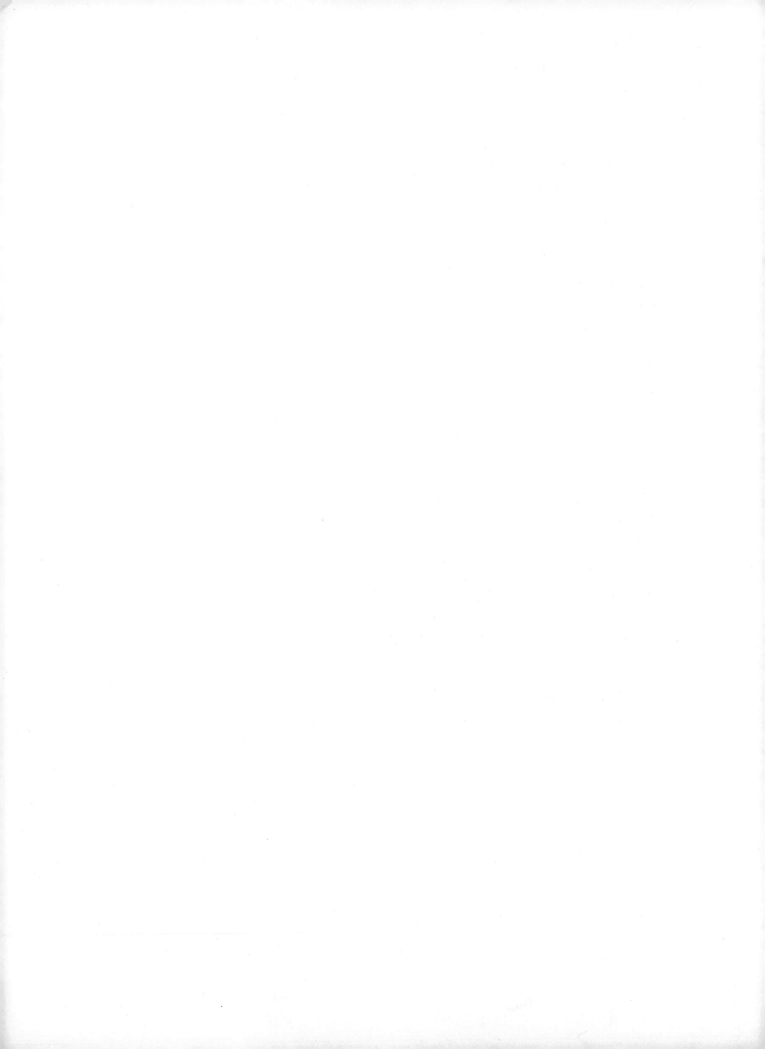

List of Illustrations

Foreword

William Blake's process of "Illuminated Printing" enabled him to make each copy of any work he published in this manner a unique product in several respects: in the color of the basic ink printed from his etched copper plates; in the retouching of the printed pages; and in their coloring by washes and various kinds of paint. Persons who have been fortunate enough to visit several of the widely scattered collections of Blake's originals—there are seventeen known copies of *The Book of Thel* in twelve different collections, for example—have found their understanding and appreciation of each work enlarged and modified by each comparison. Yet, without a phenomenal visual memory or a very sophisticated method of taking notes, one's grasp of any illuminated poem in all its variety of publication necessarily remains imperfect and incomplete. Immensely useful yet far from definitive, the *Census* of Blake's illuminated books compiled by Sir Geoffrey Keynes and Edwin Wolf 2nd in 1953, and recently reprinted, relied a good deal on collation by correspondence; the descriptions of copies are minimal, and the chronological ordering is often conjectural. As Miss Bogen now demonstrates in the case of *Thel*, the *Census* ordering of known copies from A to R (including two now untraced or unidentified) disregards some textual evidence that requires us to move copies K and R to the beginning of the list and copies I and J to the end, after O, and to reconsider previous generalizations about "early" and "late" copies.

The availability in recent years of good facsimile reproductions of one or two copies of almost every work in the canon and of color transparencies of some—thanks to Micro Methods Ltd. for the transparencies and to the Blake Trust (and Trianon Press) for facsimiles made by collotype printing and hand painting through stencils—has inspired a wide and increasingly precise study of this dimension of Blake's art. This growing interest, in turn, makes urgent the making of further facsimiles; so does the critical aging of the originals, now not far from their two hundredth year. Ultimately (ideally) there will be good color facsimiles or color photographs in quantity of all copies of each work. Meanwhile such reports as Miss Bogen's, based on examination and collation of all copies of a work, are welcome both for their information and for focusing our attention on the distinctive particulars.

The present copy of *The Book of Thel* (copy M in the *Census*; copy II-11 in Nancy Bogen's new tabulation) has not hitherto been reproduced. It came to the Henry W. and Albert A. Berg Collection of The New York Public Library in 1941 as a gift from Owen D. Young and Dr. Albert Berg. There is no earlier indication of its provenance than the signature on the flyleaf of J. Frederick Hall,

dated 1873, though plate i bears the undated name "Euphrasia Fanny" in ink, with "Haworth" added in pencil.

The Library is pleased to collaborate with the Brown University Press and the Meriden Gravure Company in producing at modest cost and with critical apparatus and commentary this color facsimile in fine-screen offset lithography —a process perhaps less impressive and certainly much cheaper than hand stenciling, yet faithful and more exactly documentary. The collaborators hope to be able to make similarly available other original Blake works in the Library's collections.

DAVID V. ERDMAN

Preface

The Book of Thel has long been considered one of the most readable and at the same time most beautiful of William Blake's prophetic works. As Max Plowman has said in *An Introduction to the Study of Blake*, *Thel* "tells a tale as plainly as if it were written in prose, yet it moves as on wings of gossamer with a lightness and poise that betoken perfect control" (p. 87). In the Blake canon it enjoys the distinction of being the first prophetic work that was issued as an illuminated manuscript—indeed, it may have been the first of those works that Blake composed. And *Thel* is probably of no small significance biographically, since it appears to be the earliest of Blake's finished works to embody the revolutionary ideas of free love and imaginative vision. Such a work, then, is valuable and deserves better treatment than it has heretofore been accorded by Blake experts. It needs a text that comes as close as possible to Blake's intention in the matter of punctuation and a commentary on the meaning of the poem in light of the improved text, the illustrations, contemporaneous works by Blake, and possible sources and analogues.

There are two standard versions of *Thel*, that of Geoffrey Keynes, which treats punctuation rather freely, and that of David V. Erdman, which relies on a comparison of several copies. These versions are far from being in agreement, and both fail to note all variants. More important, there is no single interpretation of *Thel*. Some critics view it as the story of an unborn soul's descent to and flight from this world, and among them there is no accord as to whether the escape is a positive or negative act. Others maintain that *Thel* has to do with a human being, but again there is no accord, one critic regarding Thel as endearing, another as self-deceiving and hypocritical.

This situation—the lack of both an accurately punctuated text and an adequate explanation of the poem—prompted me to undertake this critical text of *Thel* that, based on a collation of all extant originals, can be used as a basis for future popular versions and that provides a new interpretation in which I attempt to fuse a good deal of old material and some new into a whole intelligible to both the general reader and the specialist. In this endeavor I have been guided by the belief of Swinburne, an early admirer of *Thel*, who said in his *William Blake* that "there is a firm body of significance in the poem, and the soft light leaves in which the fruit lies wrapped are solid as well as sweet" (p. 203).

The notes on the text therefore consider sources, where appropriate, but primarily they emphasize a verbal relationship between *Thel* and the works of Shakespeare, Milton, and Spenser, and the Bible; show that Blake has a closer affinity to eighteenth-century religious writers of evangelical and Methodist

persuasion than to dissenting writers of the time; and avoid as much as possible esoteric traditions like the cabala, with which Blake is often (and, I think, erroneously) associated.

My case may well be overstated. Yet, in light of the revival of the idea that Blake was a mystic and is only to be understood and appreciated by the initiated, it seems to me important, even at the expense of appearing simplistic at times, to emphasize that Blake was a man of this world and very much a part of the cultural mainstream of his century.

A number of results have been obtained from this study. From the inordinate number of variants of punctuation that a comparison of all seventeen extant copies of *Thel* revealed, it is now evident that these variants, as well as such apparently curious phenomena as a single dot above the line at certain places in the text, are the result of faulty inking of Blake's relief-etched copper plates. More important, the Keynes and Wolf *Census* is shown to be inaccurate as to the order in which the copies of *Thel* were printed, raising the possibility that the *Census* arrangement of the other illuminated works is also inaccurate.

It would be gratifying to be able to conclude that, as a result of this edition, *Thel* will come to be recognized as one of the most successful of Blake's works and to rank as one of the major poems of the English Romantic period. But obviously more study remains to be done of related works as well as of *Thel* itself, particularly in the area of textual analysis. And so for the present I hope that at least one goal has been accomplished: a deeper understanding and a greater appreciation of *Thel* on the part of whoever takes up this book.

I AM especially grateful to David V. Erdman for his assistance in the preparation of my manuscript for publication; the trustees of The New York Public Library for making possible the reproduction in color of the copy of *Thel* in the Henry W. and Albert A. Berg Collection; and Carl Woodring and Elizabeth Donno for their patience and many helpful suggestions when this work was first undertaken as a doctoral dissertation at Columbia University. I thank also Paul Mellon, Lessing J. Rosenwald, and Mrs. Landon K. Thorne for their kind assistance; the American Philosophical Society for its generous support of this project; and the trustees of the Bodleian, Harvard, Huntington, Morgan, and Yale libraries and the British and Fitzwilliam museums for the use of their collections. Special thanks are also due to Judith Gustafson, who typed the manuscript; Hyman Bogen, who proofread it; and Lou Schildcrout, who lent his moral support.

Introduction

The copy of Thel *printed by Blake whose pages are reproduced in color in this book is in the Henry W. and Albert A. Berg Collection of The New York Public Library (see app. 1, copy II–11). The text that faces the facsimile pages is based on a collation of all seventeen known copies of* Thel *printed by Blake (see pp. 4–9), and references to it are by plate and line. Unless otherwise noted, all other Blake quotations are from* The Poetry and Prose of William Blake, *edited by David V. Erdman (Garden City, N.Y., 1965), and page references are to that edition.*

The Three States of *Thel* and This Edition

The Book of Thel consists of eight plates: "Thel's Motto" (plate i), the title page (plate ii), and the text (plates 1–6). They all measure approximately 6 1/16 by 4 1/4 inches, except for plate i (about 2 3/8 by 4 inches) and plate 6 (about 5 1/2 by 4 1/4 inches).

Only the date 1789 is given, and it appears on the title page. It probably corresponds to the time of composition rather than execution of the plates because a deleted line of *Tiriel* (l. 370) appears as the last two lines of "Thel's Motto," and *Tiriel* is generally dated 1789.[1] But since *Thel's* opening lines (1:6–14) concern the "children of the spring" who are "born but to smile & fall," the poem may conceivably have been commenced as early as February 1787, when Blake's much loved brother Robert died in his early twenties. As for the date Blake finished the plates of *Thel*, there is good reason to believe that this occurred after 1789, possibly as late as 1791. The lettering of the text is cursive, and thus the plates postdate *Songs of Innocence*, whose title page is also dated 1789 but whose lettering is roman, except for *The Voice of the Ancient Bard*, which is generally believed to be a late addition. As it happens, the cursive characters of plates 1–5 of *Thel* resemble those of the latter, whereas the cursive characters of plates i and 6 are larger and more uniformly slanted, like those of *Visions of the Daughters of Albion* (1793), and have the *g* with the serif on the left side that David V. Erdman claims Blake introduced into his work about 1791.[2] It would appear, then, that plates i and 6 were executed independently of plates 1–5.[3] The additional possibility exists that plates 1, 2, and 3 were executed independently of plates 4 and 5. First, the printing of plates 1, 2, and 3 is uniformly poorer than that of plates 4 and 5, and more often than not Blake had to retouch the printed page of the first three.[4] Second, the lettering on plate 4 is different; a good many of the lines of text have a downward slant, and the words tend to be larger on the right-hand side of the page. On plates 1, 2, and 3, however, the lines are uniformly horizontal, and when a word on the right-hand side is larger (as a few of them are), it is hardly perceptible.

What may have happened, then, is that about 1789, or perhaps as early as 1787, Blake began composing *Thel*; that in 1789 he made the title page plate and probably plates 1, 2, and 3; that not too long after 1789 he added plates 4, 5, and perhaps an early version of plate 6;[5] and that finally, about 1791, he executed the present versions of plates 6 and i.

With the completion of his plates Blake proceeded to issue copies of *Thel*, doing so from time to time throughout his life. Several copies bear watermarks

dated 1794 and 1815;[6] the work is listed by Blake in his prospectus of 1793 and in subsequent lists of works sent to customers in 1818 and 1827, the year of his death.[7] Blake was accustomed to listing his works according to size, and in these lists *Thel*, which Blake considered a quarto, occupies more or less the same place in relation to other works, coming after *Visions of the Daughters of Albion* (a folio) and before *Songs of Innocence* and *Songs of Experience* (octavos). The prices that Blake asked for *Thel* (three shillings in 1793; two guineas in 1818; and three guineas in 1827) went up in proportion to the prices asked for his other works.

Just how many copies of *Thel* Blake issued during his lifetime—indeed, how many were printed posthumously by Frederick Tatham, who probably acquired the plates—are facts that will perhaps never be known. Seventeen copies in all are extant: sixteen final copies, one of them lacking plate i; and what seems to be a proof copy, also incomplete. Besides the seventeen copies, there are indications that at one time others existed (see app. 1); and, as with other illuminated works, Blake issued sets of the illustrations separately.[8]

With his relief-etched copper plates Blake printed the recto pages of each of the seventeen copies in some shade of green, gray, or brown ink. And since the illustrations, and in some cases the text, are painted over with water colors, the claim that *Thel* exists in as many states as there are copies is not entirely without justification (see app. 1). However, the text itself occurs in three states, and rather than use the Keynes and Wolf *Census* designations, which do not correctly indicate the order in which the copies were printed, I have assigned each of the seventeen existing copies capital roman numerals by state and arabic numerals by copy within that state. Copies in what I call the first state (I–1 and I–2; Keynes and Wolf K and R) have *gently* as the ninth word on plate 1, line 13, and have lines 19 and 20 on plate 6; second-state copies (II-1 through II–13; a, C, A, B, D, E, F, G, H, L, M, N, and O) have the word *gentle* on plate 1, line 13, and also have lines 19 and 20 on plate 6; and third-state copies (III–1 and III–2; I and J) have *gentle* on plate 1, line 13, but lack lines 19 and 20 on plate 6. In addition, Blake's original page numbering (2, 3, 4, 5, 6) does not appear in copies II–12 and II–13; in the latter Blake renumbered the pages by hand from 1 to 8, and in copy II–12, plate 1 is numbered by hand, plate 2 renumbered "2" by hand, and plates 5 and 6 renumbered "6" and "7" by hand.

Although it is at present impossible to determine the actual dates of these states, it seems likely that, as far as their order of printing is concerned, what I call the first state came first; the second state second; and the third state third—

but this requires some explanation. First of all, crumbs of the letters of lines 19 and 20 of plate 6 are plainly visible in copy III–1, in spite of efforts by Blake to cover the area with designs by hand.[9] In other words, those lines were on plate 6 before he prepared the plates for copies III–1 and III–2; before printing those copies, Blake cut the lines away or gouged the plate. Since both the first-state and second-state copies have those lines, they must have been printed before the third-state copies. As for the order of the first and second states, since line 13 of plate 1 in the second-state copies is identical to that of the third-state copies— but not with that of the first state—it stands to reason that the second state immediately preceded the third. This means that what I call the first state came first and that the ninth word in line 13 of plate 1 was originally *gently*.

What must have happened was that after issuing copies I–1, I–2, and perhaps other copies that have since disappeared, Blake decided to change the ninth word on plate 1, line 13 from *gently* to *gentle* (see ill., p. 6).[10] This version he retained for the greater part of his life, printing twelve copies in addition to proof copy II–1, perhaps more. Then, toward the end of his life—let us say sometime after 1815, the date in the watermark of copies II–12 and II–13—he became dissatisfied with lines 19 and 20 on plate 6, deleted them, and printed copies III–1, III–2, and perhaps several other copies (see ill., p. 7).

Just why Blake made these alterations on his plates we shall probably never know with certainty. The word *gently* in the first state may have been a misprint, and the change to *gentle* merely a correction; Erdman's edition of Blake's works indicates that Blake made many errors of this kind.[11] On the other hand, it is possible that *gently* was originally intended but that Blake, realizing that *gentle* appeared twice in line 12 and once in line 13 of plate 1, changed *gently* to *gentle* for the sake of logical and syntactical uniformity and harmony:

> Ah! gentle may I lay me down, and gentle rest my head.
> And gentle sleep the sleep of death. and *gentle* hear the voice
> Of him that walketh in the garden in the evening time.
>
> <div align="right">[italics added]</div>

As for the deletion of lines 19 and 20 on plate 6—which occurred in 1815 at the earliest—possibly it is a late manifestation of a general shift of emphasis in Blake's works that occurred sometime after the turn of the century. These lines —"Why a tender curb upon the youthful burning boy! / Why a little curtain of flesh on the bed of our desire?"—are clearly a call for sexual freedom and conform

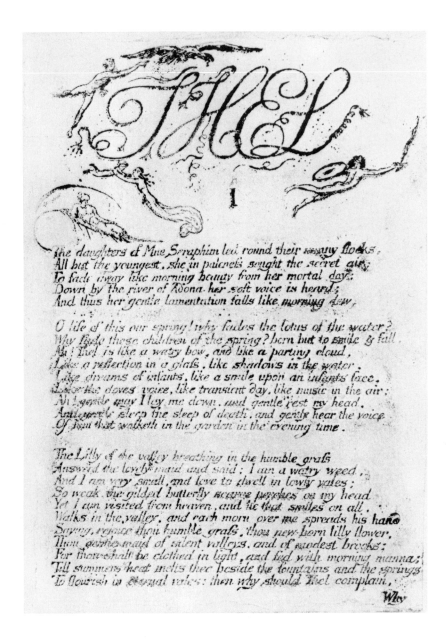

Thel, *copy II–1, plate 1, showing the transition from the first to the second state;*
both the e *and the* y *are visible in the ninth word in line 13.*

IV.

The eternal gates terrific porter lifted the northern bar.
Thel enter'd in & saw the secrets of the land unknown;
She saw the couches of the dead, & where the fibrous roots
Of every heart on earth infixes deep its restless twists;
A land of sorrows & of tears where never smile was seen.

She wanderd in the land of clouds thro' valleys dark, listning
Dolours & lamentations: waiting oft beside a dewy grave
She stood in silence, listning to the voices of the ground,
Till to her own grave plot she came, & there she sat down,
And heard this voice of sorrow breathed from the hollow pit

Why cannot the Ear be closed to its own destruction?
Or the glistning Eye to the poison of a smile!
Why are Eyelids stord with arrows ready drawn,
Where a thousand fighting men in ambush lie?
Or an Eye of gifts & graces, showring fruits & coined
 gold?
Why a Tongue impress'd with honey from every wind?
Why an Ear, a whirlpool fierce to draw creations in?
Why a Nostril wide inhaling terror trembling & affright.

The Virgin started from her seat, & with a shriek,
Fled back unhinderd till she came into the vales of
 Har

The End

Thel, *copy III–2, plate 6, showing lines 19 and 20 deleted.*

7

to the theme of breaking with restraint that dominates works of the early 1790s, like *Songs of Experience* and *Visions of the Daughters of Albion*. Since those lines are preceded by a passage on the corruption of the senses (6:11–18), Blake may well have deleted them to give more emphasis to the passage, the idea being that particular forms of restraint, like sexual inhibition, are included in the general condemnation of restraint. On the other hand, he may have recognized the inconsistency of following the general condemnation with a complaint about a particular form of restraint. Similar passages on the senses in later works (e.g., *Jerusalem* 49:34–41) omit specific reference to the sexual. Blake never lost his antipathy to organized religion and the inhibited wretches that it spawned, but sometime after the turn of the century ultimate value and the possibility of fulfillment shifted in his works away from the objective world and its delights to imagination and eternity.[12]

As far as the order of printing of copies within the states is concerned, little can be said at this time with any degree of certainty. There is no indication as to which of the first-state copies is earlier. As for the second-state copies, since a trace of the *y* of the ninth word in line 13, plate 1 is visible in copies II–1 and II–2 and not in any of the other second-state copies, probably copies II–1 and II–2 are early second-state copies, perhaps having been printed soon after the change from *gently* to *gentle* was effected on plate 1. With their 1815 watermarks, copies II–12 and II–13 are obviously late second-state copies; but it is conceivable that one or more of the other copies of the second state that are on unwatermarked paper were issued after them. There is no indication as to which of the third-state copies is earlier.

An investigation of Blake's method of coloring and comparative studies of the lettering and paper of *Thel* by means of photomacrographs or a microscope would perhaps yield further information, but this remains for some future study.

BECAUSE it seems to represent Blake's intention for the greater part of his life, a second-state copy (II–11; see app. 1), rather than a third-state one lacking lines 19 and 20 of plate 6, has been chosen for facsimile reproduction in this edition. The text that faces the facsimile pages is based on a collation of all seventeen extant copies printed by Blake. In this text Blake's spelling (e.g., "Lilly") has been retained, as have his contractions (e.g., "thro'") and ampersands. Also, the final *e* of the past participle has been omitted and an apostrophe inserted if Blake did so. The system that has been used in punctuating the text is discussed

in the section that follows. And to give as complete a picture as possible of textual problems without inundating the reader with a wholesale recording of the many variants of punctuation, the few punctuation marks that presumably Blake added by hand to the printed page are listed in Appendix 2.

Blake's Punctuation and This Edition

THE TEXT of *Thel* consists of one hundred twenty-five lines, excluding "Thel's Motto"; and all but two lines contain at least one punctuation mark. However, only thirty-nine of the punctuated lines are punctuated identically in all seventeen copies. An instance typical of the punctuation variants of the remaining eighty-four punctuated lines occurs on plate 1, line 23, after the word *light*. In copy I–1 the mark that follows *light* is a comma, and the line reads, "For thou shalt be clothed in light, and fed with morning manna." There is also a comma in copies II–4, II–6, II–7, II–8, II–9, II–10, and II–12, as well as in copies II–1 and II–2—the two copies that reflect the change from the first state to the second. But in copy I–2 and in copies II–3, II–5, II–11, and II–13 there is a period. And in the third state, copy III–1 has a comma, and copy III–2 has a period. This extraordinarily large number of variants of punctuation—of which the mark following *light* on plate 1, line 13, is only one example—does not appear to be the result of difficult and time-consuming revisions by Blake on his relief-etched copper plates. It is, rather, attributable to faulty inking or faulty printing, or both.[13]

To provide the reader with a text whose punctuation follows as closely as possible the punctuation of the text on Blake's copper plates, a special system of punctuating has been followed in the text that faces the facsimile pages of this edition. Instead of following what would be regarded as the usual procedure when dealing with a printed book—that is, collating copies of the last state—all seventeen copies of *Thel* have been collated for punctuation, and when they did not agree, the largest mark has been selected. Accordingly, if some copies had a comma in a given place, and others a period, the comma was chosen; similarly, a colon was preferred to a period, and a semicolon to a colon, comma, or period. However, the mark had unmistakably to be a comma, colon, or semicolon rather than a period. In a number of cases—for instance, after *flocks* (1:1)—the mark resembles a comma in most copies, but in no copy is it unmistakably a comma. In such cases the mark is given in the text as a period, and the possible alternative reading is recorded in Appendix 2. After the word *honey* (2:8), *voice* (3:4), and *not* (3:7), it was impossible to choose between commas in some copies and colons in others, and a semicolon is given as the probable mark on the copper plate.

If faulty inking and partial impressions were largely responsible for the variants of punctuation of *Thel*, why did not Blake attempt to make the punctuation marks more distinct on his relief-etched copper plates? The answer, apparently, is twofold. First, it is difficult to make an addition to a copper plate once it has

been etched with acid. Second, Blake did not always consult his copper plate when inserting punctuation marks by hand. For example, the mark after *vales* (1:25) in some copies is a semicolon and in others a colon, so that the mark on the plate must have been a semicolon throughout the plate's use, although faulty inking or printing often made it appear on the printed sheet as a colon. In copy II–9 Blake inserted a semicolon by hand, but in II–11 there is a handwritten colon. The same apparent casualness may help to account for Blake's failure to insure the correct printing of punctuation marks (see app. 2).

The system used in punctuating the text of *Thel* that faces the facsimile pages of this edition is obviously not definitive, since it relies at times on such subjective distinctions as whether a mark is a small comma or a large period and on such comparisons from memory as whether or not there is a radical difference between a mark on a copy at hand and one seen sometime previously under different physical conditions. But I feel confident that it is more successful than any previous system in making possible a text that approaches Blake's intention. Without such a text, it is futile to attempt to supply modern punctuation in popular editions of Blake's works.

The Prosody

THE LONG LINE that Blake used in *Thel* and most of his other prophetic works generally consists of fourteen syllables with an irregular, though rising, rhythm and is usually referred to as a septenary or heptameter.[14] Signs of its coming in Blake's work may be seen in two earlier attempts at fourteener couplets—Steelyard's song (p. 452) and Obtuse Angle's song (p. 453—the early version of *Holy Thursday*) in *An Island in the Moon* (ca. 1784). Furthermore, in the pseudo-Shakespearian blank verse of *King Edward the Third* in *Poetical Sketches* (1783) several fourteen-syllable lines may be found, for instance, "I feel it coming upon me, so I strive against it" (3. 62, p. 420).[15] Blake's early attempts at measured prose might also be mentioned: *Samson, The Couch of Death, Contemplation,* and the *Prologue to King John* in *Poetical Sketches;* and the two unfinished pieces in manuscript, beginning "Woe cried the muse" and "then She bore Pale Desire" (ca. 1780).

Perhaps most often cited by scholars as having some bearing on the development of this long line is the measured prose of Ossian (1760–63).[16] But Blake was also familiar with such contemporaneous works in measured prose as Chatterton's Saxon poems (1777–78) and Mrs. Barbauld's *Hymns in Prose for Children* (1781). Margaret Ruth Lowery has demonstrated that during the period of *Poetical Sketches* the former influenced the diction of *Gwin, King of Norway* and *King Edward the Third,* and the mood and setting of *The Couch of Death.*[17] The connections found between Mrs. Barbauld's *Hymns* and *Songs of Innocence* are too numerous to mention.

Other works in measured prose are the Collyer translations of Salomon Gessner's *Death of Abel* (1761) and Friedrich Klopstock's *Messiah* (1763), which, like Ossian's works, became popular in Blake's youth and remained so for sixty years or more. *The Ghost of Abel* (1822) and a ribald notebook poem from the 1790s (p. 491) testify to Blake's familarity with them. The inspiration for Blake's unfinished measured prose epic *Samson* may have come from two other popular eighteenth-century works—Macpherson's Ossian-like translation of the *Iliad* (1773) and George Smith Green's English translation of St.-Maur's French prose rendering of *Paradise Lost* (1745).

Prose works of a rhythmical or lyrical nature may also have had some influence on Blake's development of the long line. Eighteenth-century England abounded in such works, which were generally of a religious or ethical cast. Among them are James Hervey's *Meditations and Contemplations* (1746–47), William Sherlock's *Practical Discourse Concerning Death* (1689), Elizabeth Rowe's

Friendship in Death (1728), William Law's *Spirit of Love* (1752–54), Henry Venn's *Complete Duty of Man* (1763), and William Romaine's *Life of Faith* (1764). Hervey and Sherlock are referred to in *An Island in the Moon;* and Blake's diction in *Thel* is similar in many respects to the diction of these works.[18] Also suggested by scholars as an influence on the origin of Blake's long line is the Bible, particularly the sublime parts, such as Job, the Prophets, and Revelation.

Another connection between the long line and the Bible may be through a contemporary of Blake's named Robert Lowth. In a series of lectures on the "sacred poetry" of the Hebrews, Lowth contended that the Old Testament originally was written in a metrical form in which the lines were "very unequal in length; the shortest consisting of six or seven syllables; the longest extending to about twice that number," although in a given poem the lines were generally "not very unequal to each other." According to Lowth, there were no run-on lines, and the lines were either "Trochaic, which admit a Dactyl; or Iambic, which admit an Anapest."[19] Here and there throughout the lectures Lowth quoted passages from the Old Testament translated by himself; and quite a number of these—especially the selections from the Prophets—are in lines of fourteen syllables or more, as his version of Isaiah 14:7–8 shows:

> The whole earth is at rest, is quiet: they burst forth into a joyful shout:
> Even the Fir-trees rejoice over thee, the Cedars of Lebanon:
> Since thou art fallen, no feller hath come up against us.[20]

It is but a short step from measured prose to this kind of verse, and then but another to the fourteen-syllable line that Blake made his own. Although we shall probably never know whether this was the route Blake traveled, there is a strong possibility that he was aware of Lowth's lectures because his employer, Joseph Johnson, published them in 1787—that critical year in Blake's life when his brother Robert died and when he might have begun to compose *Thel*.[21]

Scholars have mentioned George Chapman's translation of the *Iliad*, a copy of which Blake owned, as another possible influence on Blake's long line.[22] But Chapman's lines—expertly varied in rhythm and frequently run-on—are quite complex in comparison with the simple, straightforward, and almost always end-stopped fourteener couplet that Blake used in Obtuse Angle's song and in Steelyard's song; and the same might be said for the lines of *Thel* and *Tiriel*.

Other possible influences on Blake's long line were the traditional ballad stanza, exceedingly popular in the latter part of the eighteenth century, and the

related eight-and-six hymn stanza, which the Wesleys and other eighteenth-century hymnists used extensively.[23] Blake's fourteeners and the long line of the prophetic works seem even closer to a series of works related to the eight-and-six ballad stanza—the metrical psalms of Sternhold and Hopkins. This version of the psalms was very successful during Blake's lifetime. Indeed, the British Museum *Catalogue of Printed Books* lists three hundred eighteenth-century editions, more than a third of them published after 1750, when, as Thomas Warton regretfully observed, these psalms were still being sung in the Church of England.[24]

If at no other time, Blake could have heard them sung on Holy Thursday during the celebration that he described in the first poem of that name. On Holy Thursday, after marching in a procession to St. Paul's Cathedral, the children would pray and sing there; and since there was no Church of England hymnal in the eighteenth century,[25] it is altogether possible that they sang some of the Sternhold-Hopkins psalms, which were frequently bound in with the Book of Common Prayer. Significantly, in *An Island in the Moon* both Steelyard's song and the early version of *Holy Thursday* are sung; and since they are arranged in quatrains, like many of the Sternhold-Hopkins compositions, it would not be difficult to set them to some of the psalm tunes.[26] And surely the prosodic distance between the Sternhold-Hopkins psalms and *Holy Thursday* in *Songs of Innocence* is minimal, as the quatrains that follow show.

> Twas on a Holy Thursday their innocent faces clean
> The children walking two & two in red & blue & green
> Grey headed beadles walk before with wands as white as snow
> Till into the high dome of Pauls they like Thames water flow.
>
> [*Holy Thursday*, p. 13]

> The Lord is only my support, and he that doth me feed:
> How can I then lack anything whereof I stand in need?
> In pastures green he feedth me, where I do safely lie:
> And after leads me to the streams, which run so pleasantly.
>
> [Sternhold-Hopkins, Psalm 23][27]

To discover a positive connection between the long line of *Thel* and the Sternhold-Hopkins fourteener would be gratifying, but perhaps a closer comparison of the two is needed first. It is nevertheless interesting to note three

superficial resemblances between them. First, many of the lines of *Thel*—such as, "To fade away like morning beauty from her mortal day" (1:3)—appear to be pure fourteeners, that is, iambic heptameters without any substitutions. Second, the prevailing rhythm seems to be iambic, and all but eleven lines are end-stopped. Third, since most of the lines end with an iamb, the poem echoes and re-echoes when read aloud, the effect being similar to that produced by rhyme but without the jingling quality. Perhaps, then, the distance between the prosody of the Sternhold-Hopkins psalms and the long line of *Thel* is not too great after all.

Previous Interpretations

A HISTORY of *Thel* interpretation properly begins with the publication of *The Works of William Blake* in 1893, a monumental, three-volume facsimile edition with a long section devoted to explication.[28] According to the editors, Edwin J. Ellis and William Butler Yeats, Thel is a "pure spiritual essence" who lives in a land of "un-embodied innocence" (the vales of Har) surrounded by the emblems of this state—a lily, a cloud, a worm, and a clod of clay. In part four of the poem she descends to "those who have died out of prenatal life into bodily dwellings," locates her own grave plot (symbolically her body), then flees back to the vales of Har when a voice in her grave complains of the "mysterious sorrows and limitations of the flesh" (2:92–94). This reading of the poem was adopted by a considerable number of twentieth-century scholars, including S. Foster Damon and Northrop Frye.[29]

In 1955 George Mills Harper announced that he had discovered some connections between Thel's experience in part four and Persephone's descent to the underworld as explained by Thomas Taylor, an eighteenth-century Neoplatonist.[30] Taylor, in his *Dissertation on the Eleusinian and Bacchic Mysteries,* had contended that the Persephone myth represents the descent of an unborn soul to this world of woe. According to Harper, Blake was in general agreement with Taylor's belief that material existence is hell and the body is the sepulcher of the soul. To support his idea, Harper offered analogues between three of Taylor's works, including the *Dissertation,*[31] and a number of images in part four of *Thel,* including the "northern bar" of the "eternal gates" through which Thel passes, the "terrific porter" who guards it, and the first sight that she sees when beyond the gates—"the couches of the dead, & where the fibrous roots / Of every heart on earth infixes deep its restless twists."

Not all supporters of the Ellis-Yeats interpretation have been entirely satisfied with it. Some, realizing that antimaterialism is central to this interpretation, noted that in several works belonging to the same period as *Thel*—notably *The Marriage of Heaven and Hell* (ca. 1790–93) and *Visions of the Daughters of Albion* (1793)—Blake had declared just the opposite: "every thing that lives is holy." This led them to suspect that Thel's flight back to the vales of Har at the end of the poem occurs because of a flaw in her character. For instance, Mona Wilson observed that "there is a hint in the last illustration that Thel fears death into the body overmuch."[32] Mark Schorer arrived at the same conclusion but suggested that Thel is fearful of the sexual act.[33] Quite recently Peter F. Fisher went even further, characterizing Thel's behavior as "petulant" and calling her flight

a "suicide."[34] Others—like Pierre Berger, Max Plowman, and Harold Bloom—discovered references to Thel and the Lilly, Cloud, and Clod as mortal beings in the first three parts of the poem (e.g., 3:22), and their lines of argument became hopelessly confused. According to Berger, Thel is a soul at the beginning of the poem, then becomes a young girl doomed to die, and in the end turns into a soul again.[35] In one part of his commentary Plowman speaks of Thel as "already in this world" at the beginning of the poem; but elsewhere he remarks that she is "no human girl, but the soul itself at the moment of its separation from the innocence of Eden."[36] Similarly, Bloom says that although Thel is in a "state of pre-existence . . . her state is a mortal one," and in the end, "confronted by the realization that she will have suffered life only to have attained again to a state of unrealized potential, Thel chooses not to have lived."[37]

Not long ago H. M. Margoliouth and Robert Gleckner, persuaded that Thel is a human being throughout the poem and that the poem deals with innocence and experience as human values (rather than those of the unborn and embodied worlds as in Bloom), abandoned the Ellis-Yeats interpretation altogether. Margoliouth proposed that what Thel views and flees from in part four is "spiritual death," and he compared the landscape beyond the "eternal gates" in *Thel* to that in *The Garden of Love*. This experience is necessary, he says, for Thel to realize that she is rightfully mistress, beauty, and queen of the vales of Har. But Margoliouth does not go on to discuss the nature of the vales of Har or why it is profitable to be their ruler.[38]

Assuming that one of the most important elements of Blake's philosophical system is his concept of a higher innocence, Gleckner makes a distinction between Thel and the daughters of Mne Seraphim, whom, he rightly observes, she leaves at the beginning of the poem (1:1–3); he also implies a distinction between the vales of Har and Mne Seraphim, their respective realms. The daughters are higher innocents, having undergone a mortal life of self-sacrifice in exchange for "eternal delight." The action of the poem, including that of part four, is concerned with the successive attempts of the Lilly, Cloud, and Clod of Clay to teach Thel how to be self-sacrificing. But she is unco-operative, being vain and self-deceiving, and these attempts prove futile. In the end she flees, though from what kind of experience Gleckner does not make clear.[39] In any case, her flight back to the vales of Har, which Gleckner styles a "synthetic, unreal paradise," indicates that she is obstinately content to remain as she is.

Gleckner's interpretation of *Thel* is the most thorough and therefore merits

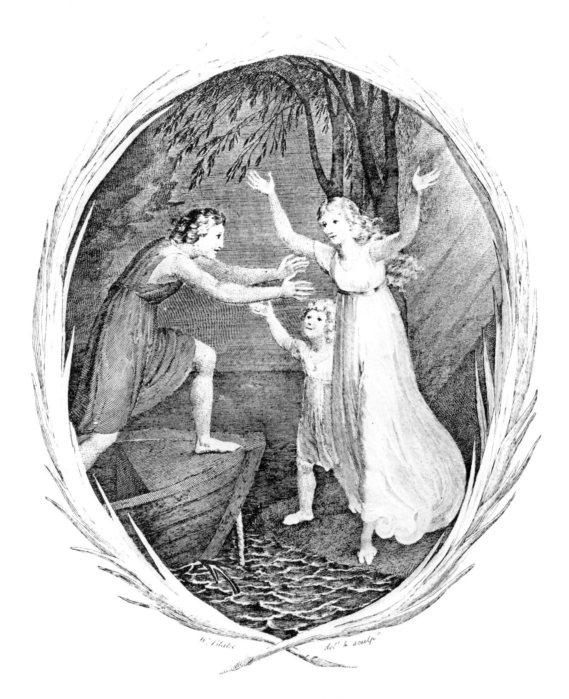

Blake's design for Thomas Commins's Elegy, *1786.*

full consideration; but surely he is mistaken in his contention that Thel is an antiheroine. First of all, Blake's depiction of Thel in the illustrations to the poem calls to mind the agreeable figures in the designs of *Songs of Innocence* and the young lady in Blake's plate for Thomas Commins's *Elegy* (1786), who welcomes her beloved with cheerful countenance and open arms (see ill., p. 18). Moreover, the terms that refer to Thel generally leave a positive impression. The Clod addresses her as a "sweet maid" and "beauty of the vales of Har"; more important, she is similarly referred to in the narrative (e.g., 1:16, 5:7), which appears to be impersonal and objective. Of course, Thel is called a "virgin" now and then, and we know that during the early part of his career Blake was firmly opposed to sexual restraint. But he used the word in a positive as well as a negative sense. In *Visions of the Daughters of Albion*, for instance, he made a distinction between the hypocritical prostitute, who sells joy "in the night, / In silence. ev'n without a whisper, and in seeming sleep," appearing like a "modest virgin" in the morning (6:7–13, p. 48), and Oothoon, who describes herself as a "virgin fill'd with virgin fancies / Open to joy and to delight" (6:21–22, p. 49). Although Thel is not as effusive as Oothoon about the joys of sexual love, neither is she falsely modest; at least she does not react with shock and horror to the Cloud's account of his erotic experience with the "fair eyed dew" (3:12–16), as one might expect if she were hypocritical, like the prostitute. Thel's sweetness and the lyrical beauty of the poem, then, seem nearly inseparable.

Finally, whether judged by eighteenth-century standards or Blake's own, Thel appears to be a young lady of sterling character. Unpitied in her distress— or so she believes—she is still able to view the plight of another with compassion:

Is this a Worm? I see thee lay helpless & naked: weeping,
And none to answer, none to cherish thee with mothers smiles.

[4:5–6]

And Thel, like Blake himself, can see imaginatively as well as objectively. Just as Blake, in writing about a thistle, revealed that

What to others a trifle appears
Fills me full of smiles or tears;
For double the vision my Eyes do see,
And a double vision is always with me.

> With my inward Eye 'tis an old man grey;
> With my outward a Thistle across my way,[40]

so Thel sees a worm as a worm, but as something else as well:

> Art thou a Worm? image of weakness, art thou but a Worm?
> I see thee like an infant wrapped in the Lillys leaf.
>
> [4:2-3]

And Oothoon displays the same double vision on encountering a marigold:

> Art thou a flower! art thou a nymph! I see thee now a flower;
> Now a nymph! I dare not pluck thee from thy dewy bed.
>
> [1:6-7, p. 45]

Thel, then, is not an antiheroine but a positive figure, like Oothoon and like Blake himself when he appears in his own works.

A New Interpretation

IN THE tradition of the eighteenth century, *Thel* is a narrative poem with a didactic purpose. It tells the story of a young girl, not a disembodied soul, who is not hypocritical or even self-deceiving but is as virtuous and transparent as the creatures with which she associates. In a word, she is the heroine of the poem and, like Oothoon, represents Blake's alter ego. Her story is that of every young person: she seeks and eventually finds a meaningful role in life; and during the course of her search Blake elaborates on the theme that man ought to love openly and think freely, like the rest of creation—a theme of the more or less contemporaneous *Songs of Innocence and of Experience*, *The Marriage of Heaven and Hell*, and *Visions of the Daughters of Albion*. A survey of some of the literary traditions to which the poem appears to be related suggests that this interpretation is valid.[41]

One of these traditions is the pastoral elegy. The pastoral setting and elegiac tone of *Thel* are apparent from the title page; on it Thel is shown as a young lady with a shepherd's crook, and she stands under what appears to be a willow tree, a traditional symbol of sadness. The poem itself opens in a fashion suggestive of the beginning of a pastoral elegy: the daughters of Mne Seraphim tend "sunny flocks" and are therefore shepherdesses of a sort. Thus, Thel's departure from their midst corresponds in the pastoral elegy to the shepherd-mourner's abandoning his flock and going off by himself.

Once alone Thel proceeds to grieve, the cause of her sadness apparently being the brevity of all life, including her own—not unlike the pose of many shepherd-mourners:

O life of this our spring! why fades the lotus of the water?
Why fade these children of the spring? born but to smile & fall.
Ah! Thel is like a watry bow. and like a parting cloud.
Like a reflection in a glass, like shadows in the water.
Like dreams of infants, like a smile upon an infants face,
Like the doves voice, like transient day, like music in the air.

[1:6–11]

The next two lines of her complaint—"Ah! gentle may I lay me down, and gentle rest my head. / And gentle sleep the sleep of death"—remind one of similar longings of other shepherd-mourners, among them Spenser's Colin, who wails, "Why doo we longer liue, (ah why liue we so long)."[42]

Here the likeness between *Thel* and the pastoral elegy ends—unless Thel's

subsequent meeting with the Lilly, Cloud, and Clod corresponds to the commiseration of nature with the griever, another convention of that genre. Nevertheless, it is important to bear in mind, especially in light of Gleckner's interpretation of *Thel*, that the shepherd-mourner of the pastoral elegy is usually a sympathetic character.

Thel also has elements of folklore and romance, ballad and fairy tale. One such element is the inferior creatures' ability to speak; in *Thel* the Lilly, Cloud, and Clod of Clay all speak, and the Worm weeps. Another element is a regal society; the fairies of England are always portrayed as belonging to such a society. In *Thel* each of the major characters is a monarch of a sort: the Lilly watches over a "numerous charge," the Cloud rests on an "airy throne," the Clod has been given a "crown that none can take away," and Thel is called the "queen of the vales" and sits on a "pearly throne." Moreover, these personages are not monarchs in name only. Here and there in the poem one finds them acting the part with the mock imperiousness of regal figures in ballads and fairy tales. For example, Thel does not ask the Cloud to give her information but commands him to do so: "O little Cloud, the virgin said, I charge thee tell to me, / Why thou complainest not when in one hour thou fade away" (3:1–2). The Clod behaves similarly toward Thel's "moans" and "sighs," explaining, "I heard thy sighs. / And all thy moans flew o'er my roof, but I have call'd them down" (5:14–15). And the Cloud assumes the same tone with the lowly Worm, momentarily playing the role of queen's chamberlain: "Come forth worm of the silent valley, to thy pensive queen" (3:29).

Finally, Thel seems bent on a quest of some kind, going sadly or being sent from one personage to another—from Lilly to Cloud (2:13–16), from Cloud to Worm (3:27–29)—in a fashion typical of romance. And indeed, since she is identified as the "youngest" of a number of "daughters," a reader of ballad and fairy tale would ordinarily expect her to be successful in her quest.[43]

Another tradition related to *Thel* is that of the earthly paradise. Har, where the majority of the action occurs, is such a place—like the Garden of Eden, the Garden of Adonis, Arcadia, the country of Beulah, and many other gardens with which Blake would have been familiar. Blake also used *Har* for the name of a character in *Tiriel* (ca. 1789), and Har's history seems to be referred to in *Song of Los* (1795). To several critics the character Har represents degenerate poetry; but he may instead be Tiriel's concept of God, changing in outward aspect—for instance, from a little child to a stern old man—with Tiriel's outlook.[44] Im-

portant here is that the sources of Har suggest Near Eastern mountains, the golden age, and the gods of possibly East and West, and that both the place where the Har of *Tiriel* lives and the vales of Har in *Thel* bear a resemblance to an earthly paradise (see n. 2:1).

In *Tiriel*, Har, Heva, and Mnetha share milk and honey; they sit on fleeces, so there must be sheep or lambs nearby; and there are birds, though in cages, to which Har feeds cherries. In *Thel* it is springtime in the vales of Har; the only cloud in the sky is a "tender" one, and there is mention of milk, honey, wine, oil, perfume, warbling birds, innocent lambs, fountains, springs, sweet-smelling flowers, and a river (see n. 1:4). All of the creatures seem to live in utmost harmony, and physical love is accepted as a natural act, the Cloud being a type of "youthful burning boy" without any "tender curb" on his desire.

Nevertheless, the vales of Har are no heavenly paradise, for there are clear indications that, exotic as they may be, they are located on Earth. First, the three major divisions of creation—animal, vegetable, and mineral—are represented by the Worm, Lilly, and Clod. Then, too, at least three of the elements traditionally regarded as essential to our world are symbolized by the Lilly, Cloud, and Clod: the Lilly calls herself a "watry weed," and the other two, of course, represent air and earth.[45] Third, the inhabitants of the vales also serve as examples of typical stages in the life of this world's creatures: infancy, childhood, youth, and parenthood. The Lilly, referred to as "new-born" and "little virgin," must be a child; the Cloud, who courts the "fair eyed dew," and the Clod, who supplies the baby Worm with "milky fondness," represent the other stages. And the creatures of the vales of Har—like the creatures of the laughing, joyful "valleys wild" in *Songs of Innocence*—are evidently subject to change and death: the Lilly speaks of the coming summer when she will be melted by the heat and afterward "flourish" in "eternal vales"; and the Cloud's union with the "fair eyed dew" at dawn, which will culminate in their "bearing food" to the "tender flowers," can only result in his dissolution.

A possible meaning for the word *Mne* may provide us with a final indication that the vales of Har are on Earth and may clarify the relationship between Har and Mne Seraphim. According to the probable source, *Mne* could mean "moon" (see n. 1:1); and after her departure from the daughters of Mne Seraphim, Thel is discovered "down" by the river of Adona (1:4).[46] Therefore, perhaps Thel is *beneath* or *below* Mne Seraphim—in part of the *sublunary* world.[47] Also, there are indications that Mne Seraphim is a realm of spirit. In the vales of Har, the lamb,

though "innocent," must wipe his mouth of "contagious taints"; but in Mne Seraphim there are "sunny," or uncontaminated, flocks; and the air of the vales is "secret," or dark, yet the sun shines there, too. From these possibilities it could follow that the river of Adona is a dividing line between the vales of Har and Mne Seraphim. And this idea should not seem strange because river boundaries between realms of matter and spirit are traditional in Western literature—in *Pilgrim's Progress*, for instance, in which Christian and Hopeful cross a river in order to reach the Celestial City.[48]

Thel also seems to be related to a series of late eighteenth-century works for children whose purpose was to inculcate a love of God and at the same time provide a little background in natural philosophy. Like the virtuous or potentially virtuous children in those works, Thel is in the position of learner, and she is taught quite similar lessons. An examination of some of the prominent ideas in two of the most popular moral tales for children—Mrs. Trimmer's *Fabulous Histories* (1786) and Mary Wollstonecraft's *Original Stories from Real Life* (1788)[49] —sheds further light on Thel's status and role in the vales of Har. In *Fabulous Histories* a Mrs. Benson says of the idea of mutual benevolence, "I consider that the same almighty and good Being who created mankind made all other living creatures likewise, and appointed them their different ranks in creation that they might form together a community, receiving and conferring reciprocal benefits."[50] In *Thel* this idea is voiced by the Cloud—"every thing that lives, / Lives not alone, nor for itself" (3:26–27)—and iterated by the Clod—"we live not for ourselves" (4:10).

The corollary "every living creature that comes into the world has something allotted him to perform" is also emphasized in *Fabulous Histories* and similar works.[51] As for *Thel*, this corollary seems to be the point on which the action of the first three parts turns. The Lilly, who responds to Thel's lonely plaint on entering the vales, has her tasks to perform, as Thel points out to her:

> O thou little virgin of the peaceful valley.
> Giving to those that cannot crave, the voiceless, the o'ertired:
> Thy breath doth nourish the innocent lamb, he smells thy milky garments,
> He crops thy flowers, while thou sittest smiling in his face,
> Wiping his mild and meekin mouth from all contagious taints.
> Thy wine doth purify the golden honey; thy perfume,

Which thou dost scatter on every little blade of grass that springs,
Revives the milked cow, & tames the fire-breathing steed.

[2:3–10]

And the Cloud has his task, too—he feeds the flowers. But what about Thel? She senses that she must have some purpose, but clearly it is not the same as that of the Lilly, for she sadly concludes her list of the Lilly's tasks by saying,

But Thel is like a faint cloud kindled at the rising sun;
I vanish from my pearly throne, and who shall find my place.

[2:11–12]

Nor is her purpose the same as the Cloud's:

I fear that I am not like thee;
For I walk through the vales of Har, and smell the sweetest flowers;
But I feed not the little flowers: I hear the warbling birds,
But I feed not the warbling birds. they fly and seek their food.

[3:17–20]

Indeed, her conclusion here is one of utter dejection:

But Thel delights in these no more because I fade away,
And all shall say, without a use this shining woman liv'd,
Or did she only live. to be at death the food of worms.

[3:21–23]

In spite of their concern for Thel, the Lilly and Cloud are curiously unperturbed by her problem. The Lilly assumes that Thel will end in "eternal vales" like herself, for on apprising Thel of her own happy lot, she asks, "Then why should Thel complain, / Why should the mistress of the vales of Har, utter a sigh" (1:25–2:1). And the Cloud is overjoyed on learning that Thel might eventually be the "food of worms," exclaiming to her, "How great thy use, how great thy blessing" (3:26). But are they correct—should Thel be satisfied and cease complaining? In the context of *Fabulous Histories* and similar works the answer is no, one reason being that the Lilly and Cloud, as part of brute creation, simply do not have the capacity to understand Thel fully. By supposing that Thel will "flourish" in "eternal vales," the Lilly reveals that she views Thel as just an-

other lily, not as a human being. Similarly, the prospect of Thel's being the "food of worms" brings joy to the Cloud because it corresponds to his own lot. To him Thel might as well be another cloud, and he says as much when he addresses her as "virgin of the skies."

Whether Thel has a function in addition to being the food of worms we are not told in the first three parts of the poem. But there is an indication at the end of part three that she may find a solution to her problem in part four. The Clod's invitation to Thel to visit her house at the end of part three seems to be an offer of help. Furthermore, an idea stressed in *Fabulous Histories* and *Original Stories* makes it clear that help is being offered by the Clod. As a Mrs. Mason says in *Original Stories*, God cares for all beings, even the "meanest creature" and is especially kind to "helpless creatures"—those that "cannot complain"; God alone "understands their language."[52] In *Thel*, God works through the Clod, caring for her and at the same time considering her his representative. As the Clod explains to Thel,

> Thou seest me the meanest thing, and so I am indeed;
> My bosom of itself is cold. and of itself is dark,
> But he that loves the lowly, pours his oil upon my head,
> And kisses me, and binds his nuptial bands around my breast.
> And says; Thou mother of my children, I have loved thee.
> And I have given thee a crown that none can take away.

[4:11–5:4]

Acting in God's behalf, the Clod succors the Worm with "milky fondness"; but Thel learns this only after she has viewed the Worm and pitied its forlorn condition:

> Ah weep not little voice, thou can'st not speak, but thou can'st weep;
> Is this a Worm? I see thee lay helpless & naked: weeping,
> And none to answer, none to cherish thee with mothers smiles.

[4:4–6]

Thel's situation is somewhat analogous to the Worm's. Thel, too, complains and seemingly goes unnoticed—"I complain, and no one hears my voice," she tells the Cloud (3:4). Yet her cries have reached the Lilly (one of God's favorites) and also the Clod, whose invitation to enter her house seems to be given in the

same spirit as the "milky fondness" was to the Worm:

> Queen of the vales, the matron Clay answerd; I heard thy sighs.
> And all thy moans flew o'er my roof, but I have call'd them down:
> Wilt thou O Queen enter my house, 'tis given thee to enter,
> And to return; fear nothing. enter with thy virgin feet.
>
> [5:14–17]

Two final traditions related to *Thel* are those of the otherworld of evil spirits and the "Graveyard School" of English literature.[53] In part four of the poem, one cannot help noticing how similar the landscape of the place that Thel visits is to an otherworld of evil spirits, or a hell. This land has a gate that is guarded by a "terrific porter." It is dark and perhaps cold, for the porter lifts the "northern bar" of his gate to allow Thel to enter (see n. 6:1). The inhabitants of the land are in a lamentable condition; and, though they are not diabolical, there is a general lack of love and wisdom in the land, for the voice from the grave complains of the prevalence of malice ("destruction" to the "Ear") and dissimulation ("poison" to the "Eye"). And the voice goes on to particularize, enumerating seven faults or sins: veiled hostility ("Eyelids stord with arrows ready drawn, / Where a thousand fighting men in ambush lie" [6:13–14]); flaunting ("an Eye of gifts & graces. show'ring fruits & coined gold" [6:15]); cunning ("a Tongue impress'd with honey from every wind" [6:16]); shallow or unappreciative listening ("an Ear, a whirlpool fierce to draw creations in" [6:17]); fear ("a Nostril wide inhaling terror trembling & affright" [6:18]); excessive modesty ("a tender curb upon the youthful burning boy" [6:19]); and sexual abstinence ("a little curtain of flesh on the bed of our desire" [6:20]).

Some of the features of this hell—such as the "secrets" that Thel sees and the "dolours" and "lamentations" that she hears—are quite similar to those in the evil otherworlds of *Paradise Lost, Pilgrim's Progress,* and the *Divine Comedy* (see nn. 6:1–6:10). But perhaps more important is that Thel acts like any visitor to a hell: she sees, she wanders, she listens, and she waits in silence.[54] Even her behavior at the end of the poem, when she starts from her seat in fright, shrieks, and flees, is not unusual for a visitor to such a place. Dante experiences a similar shock in canto 17 of the *Inferno*, although he, too, has been told that there is nothing to fear.

The land of the fourth part of *Thel* also resembles a graveyard. Thel sees

"couches of the dead" (6:3), waits "beside a dewy grave" (6:7), and sits by her own "grave plot" (6:9). Indeed, one is reminded of Young's *Night Thoughts* (1742–45) and Hervey's *Meditations among the Tombs* (1746), two of the principal graveyard poems.

These writers and a good many like them, including the Wesleys, shared the idea that adult life was a kind of death and hell—or a "vale of tears," as they would have put it. They claimed that instead of being pure and undefiled man's heart (his will and passions) was rooted in earthly things (see n. 6:3–4); but they also said that man's earthly lot was not hopeless because he was capable of removing his heart from earthly things (he was capable of moral reformation and spiritual enlightenment). Although Blake would have disagreed on specific moral issues, like sexual freedom, he seems to have pursued the same line of thought in part four of *Thel*. On entering the "land unknown," Thel sees "fibrous roots" of human hearts with their "restless twists" deep in the earth, or the impure adult world full of its vain strivings. But the voice from the grave seems to say that this world can be different, for the key word of its message is *why*—why is man (symbolized by the eyelid, eye, tongue, ear, and nostril) so full of hostility, flaunting, cunning, shallow listening, and fear? Why is he so modest? And why does he allow a "little curtain of flesh"—a maidenhead, symbol of the moral restraints imposed upon him by organized religion—to interfere with the fulfillment of desire?

TO COMPLETE the interpretation of *Thel* and review the narrative, the youngest of the daughters of Mne Seraphim, Thel, sets out for the "secret air" of earth. Since Mne Seraphim appears to be a realm of spirit, this journey may be viewed as the descent of a soul into generation, or birth.[55] Significantly, it is spring when the journey occurs, the time of birth and rebirth.

Once "down" by the river of Adona and in the vales of Har, Thel utters a lamentation, the theme of which has already been revealed in the narrative: she is to "fade away like morning beauty from her mortal day," or die.[56] She begins her lamentation with a concern for the fate of all creatures, including the "lotus of the water," or the water lily; then she likens herself to things which suggest evanescence, thereby indicating a similarity between the situation of all creatures and her own. Next she voices a longing for death; but she wants it to be "gentle," or gradual and painless, unlike that of the other "children of the spring," who, while fading like herself, sometimes "fall," or die, suddenly and by

violence. She concludes her plaint with a wish to "gentle hear the voice" of God, "him that walketh in the garden in the evening time" (1:14); that is, she desires that God's treatment of her be different from his treatment of Adam and Eve after he walked "in the garden in the cool of the day" (Gen. 3:8).

As if in response to Thel's last words, the Lilly attempts to comfort Thel by telling her of God's promise of an afterlife in "eternal vales." Thel, however, recognizes that this promise was made to the Lilly in return for feeding the lamb, refining the honey, and refreshing the cow and steed. Without a comparable role, it seems to Thel that she has been born only to die, and she ends by likening herself to an evaporating cloud. Thel's experience with the Cloud, to whom the Lilly directs her, more or less follows the same pattern. When Thel asks why he makes no complaint about the brevity of his life, the Cloud equates his dissolution with "tenfold life" and "raptures holy"; then he describes his union with the "fair eyed dew" and their feeding the flowers, which results in his dissolution. But again Thel is quick to see that she is different, and in despair she concludes that "all shall say, without a use this shining woman liv'd, / Or did she only live. to be at death the food of worms" (3:22–23).

The Cloud then refers Thel to the Worm, by whose helplessness and apparent forlornness Thel is struck. But then, succoring the Worm with "milky fondness," the Clod explains her position as a representative of God. Furthermore, the Clod has heard Thel's lament, and at the conclusion of part three she seems to offer assistance to Thel in the form of an invitation to her house, making it clear that it is only to be a visit and that Thel will be free to return to Har. Thel apparently accepts the invitation, for at the beginning of part four she enters a new land through "eternal gates" guarded by a "terrific porter." After viewing the gloomy sights of this land, which appears to be a kind of hell and graveyard epitomizing man's life on earth, Thel sits beside her own grave plot and listens to a voice within utter a protest against such a life, then starts, shrieks, and flees back to the vales of Har.

The turning point of the first three parts of the poem occurs when Thel reacts to the Clod and her message. Formerly she believed that God was primarily concerned with punishment, but now she sees her error and knows that God is full of gentleness and love:

> The daughter of beauty wip'd her pitying tears with her white veil,
> And said. Alas! I knew not this, and therefore did I weep;

That God would love a Worm I knew, and punish the evil foot
That wilful, bruis'd its helpless form; but that he cherish'd it
With milk and oil, I never knew; and therefore did I weep,
And I complain'd in the mild air, because I fade away,
And lay me down in thy cold bed, and leave my shining lot.

[5:7–13]

Implicit in those lines is one of the two solutions to Thel's problem of purpose. Since she has only recently descended from the realm of Mne Seraphim, or been born, she is too young or immature to have a "use."[57] She is like the Worm in this respect, and she is closest to it in the eighteenth-century order of creation. Like an "infant wrapped in the Lillys leaf" and dining on "milky fondness," the Worm too has no purpose. But what will happen when both of them grow up? The Worm will be a consumer of carrion, but what of Thel?

The answer is given in part four. The assistance that the Clod offers Thel the young human being is a glimpse of her own future adult life among mankind,[58] and the complaining voice from the grave in the "land unknown" appears to be that of another, older Thel—Thel as she will someday be.[59] This voice is concerned with sex; hence, it must be that of a mature human being. And since the voice issues from Thel's "own grave plot," it could belong to another self. Thel's "use," then, would be to play the role of protester in a world in which man does not love his fellow as he should—that is, as the creatures of Har love one another.

The life-in-death atmosphere of the "land unknown" is explained by "Thel's Motto." The Eagle and the Mole of the motto probably symbolize double vision and "Single vision."[60] Double vision is represented by Thel, who sees more than meets the eye; single vision is represented by the other creatures of Har, whose reality seems limited to themselves and their milieu. Therefore, the motto's first question is, Does Thel or one of the other creatures know what is in the pit? Since *pit* can signify both the grave and hell (see n. i:1), the answer seems to be Thel, for she alone has visited the "land unknown." But that land is also the interior of the Clod's house, and Thel's experience there results from the Clod's invitation; so the real answer is that both Thel and the Clod know what is in the pit, but their knowledge is of different orders.

As for the second question of the motto—"Can Wisdom be put in a silver rod? / Or Love in a golden bowl?"—from the way it is phrased the answer must be no. If Blake had wanted an affirmative answer he would have asked, Can

Wisdom *not* be put in a silver rod *nor* Love in a golden bowl? Love and wisdom are not to be associated with the rod and bowl because human authority, which they represent, is ultimately responsible for the life-in-death atmosphere of the "land unknown."[61] Seen in this light, "Thel's Motto" supports the theme of the poem and at the same time carries it one step further. Although both Eagle and Mole see man's world, only the Eagle—or one who possesses double vision— can clearly perceive its fallen nature, its mind-shackled wisdom and morality. Responsible for this lamentable situation are the "privy admonishers of men,"[62] who bear a silver rod, and the priests in black gowns, who think they can deal out love in a golden bowl and whose own motto is Thou shalt not.

If Thel really will find her purpose as a protester, why does she, in the strange conclusion of the poem, start from her seat, shriek, and flee back to the vales of Har? The answer is that, having been surrounded by pure love in Har, Thel is shocked by the loveless human world and the prospect of playing in it the role of protester. And so she runs, not away from anything—nothing threatens her and she has been promised a safe return—but back to the present and her innocent youth, where she belongs. Thel's role in the "land unknown" is thus not at all like that of Persephone, a mythical being, but like the roles of Dante and Thomas the Rhymer; her lot is similar to that of the shackled boy in *A Little Boy Lost* and Ona in *A Little Girl Lost*, except that their wisdom and love are blighted and blasted prematurely, whereas Thel will someday speak her mind, like Oothoon, who unabashedly declares for the "vigorous joys of morning light"; and her literary descendants are L. Frank Baum's Dorothy in *The Wizard of Oz* and Lewis Carroll's Alice.

Text

Plate i

THEL'S *Motto,*

Does the Eagle know what is in the pit?
Or wilt thou go ask the Mole;
Can Wisdom be put in a silver rod?
Or Love in a golden bowl? i:4

THEL's Motto.

Does the Eagle know what is in the pit?
Or wilt thou go ask the Mole:
Can Wisdom be put in a silver rod?
Or Love in a golden bowl?

Plate ii

Some of the major figures of *Thel* are represented here. Thel holds a shepherd's crook. In costume and hair style she resembles the young lady in Blake's illustration for Commins's *Elegy* (see ill., p. 18). The flowers, which seem to be garden lilies, are from copy to copy variously colored purple, light purple, purplish red, reddish orange, vivid red, strong reddish brown, pink, yellow, dark yellow, and dark blue (see n. 1:15). A bud is closest to Thel and symbolizes or points to her innocent state. The nude male and clothed female represent the Cloud and his consort, the "fair eyed dew." Scenes of similar joyousness indicated by the gesture of outstretched arms can be found in *Songs of Innocence*; for example, the illustration for *Nurse's Song*. The overspreading branch is also a common motif in Blake's early illuminated works. At times it is an emblem of protection or benediction, as in the first illustration for *The Little Black Boy*, in which the boy's benedictive gesture is balanced compositionally by the outward thrust of the branch; elsewhere it is expressive of joy, balancing the outstretched arms gesture, as in *Nurse's Song*. The dark area to the right of Thel's feet may represent water. The overall design suggests late eighteenth- and nineteenth-century paintings of river scenes.

The illustration seems to serve as a bridge between "Thel's Motto" and the poem proper. As on title pages of subsequent works, like *America,* the page is divided into two complementary parts. The soaring eagles and the floating human being beneath the right-hand eagle represent the imaginative aspect of human existence— "Wisdom" in the "Motto"; the Cloud, "fair eyed dew," and flowers represent the sensual aspect, or "Love." Having not yet determined what her role in life will be, Thel stands aloof from those two aspects, as she does at the beginning of the text of the poem; yet her head is in line with the imaginative, and her body with the sensual.

No two copies are colored alike, although copies II–12 and II–13 are similar (see app. 1). Both also contain a framing line, and in copy II–13 the figures are outlined in black.

THE
BOOK
of
THEL

The Author & Printer Will.ᵐ Blake, 1789.

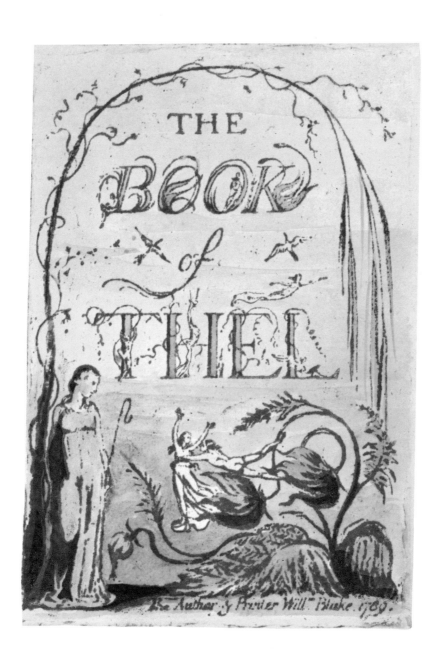

THE
BOOK
of
THEL

The Author & Printer Will.m Blake. 1789.

Plate 1

Most, if not all, of the figures in this illustration can also be found on plate ii: the man pointing to the eagle and the man with the sword and shield suggest the floating man beneath the soaring eagle on plate ii; the child and the woman holding it suggest the child and woman who stand in the center and on the right stem of the *H* of "THEL" on plate ii; the reclining figure here suggests the figure on the *L* on plate ii; and the plant he reclines on can be found on the *O* and *K* of "*BOOK*" on plate ii. It is almost as if Blake had scanned the upper portion of plate ii with a microscope and found more there than first met his eye. A similar piece of visual strategy is employed on plates 1 and 2 of *America*, in which, in the left-hand corner of plate 1, there is a figure of a man whose bonds compel him to sit in an almost fetal position; on plate 2 the same figure, considerably enlarged and occupying a central position, bursts up through the ground as if being born.

Like the illustration of plate ii, the design of plate 1 of *Thel* seems to be divided into two parts. The man pointing is balanced compositionally by the man with the sword and shield, implying that they are both associated with the eagle (see n. i:1–2); the child, woman, and reclining man may represent stages in the biological life of man (in the poem the baby Worm reclines on the Lilly's leaf and is succored by the Clod). As on plate ii, the atmosphere is one of freedom of movement and joy, again suggestive of similar scenes in *Songs of Innocence*.

There is considerable variation of detail among the copies. In most the sky has been colored. In copies II–3, II–8, II–11, II–12, III–1, and III–2 the text area of the plate has been colored; in copies II–7 and II–8 the eagle has been outlined in black; in copy II–7 a vine has been painted in on the left-hand side and bottom, and a fern has been painted in on the right-hand side; in copies II–12 and II–13 there is a framing line, and a tree has been painted in on the left-hand side, extending to the bottom in the latter copy; and in copy II–13 the figures have been outlined in black.

THEL

I

The daughters of Mne Seraphim led round their sunny flocks.

All but the youngest; she in paleness sought the secret air.

To fade away like morning beauty from her mortal day:

Down by the river of Adona her soft voice is heard:

And thus her gentle lamentation falls like morning dew. 1:5

O life of this our spring! why fades the lotus of the water?

Why fade these children of the spring? born but to smile & fall.

Ah! Thel is like a watry bow. and like a parting cloud.

Like a reflection in a glass, like shadows in the water.

Like dreams of infants, like a smile upon an infants face, 1:10

Like the doves voice, like transient day, like music in the air;

Ah! gentle may I lay me down, and gentle rest my head.

And gentle sleep the sleep of death. and gentle hear the voice

Of him that walketh in the garden in the evening time.

The Lilly of the valley breathing in the humble grass 1:15

Answer'd the lovely maid and said; I am a watry weed,

And I am very small, and love to dwell in lowly vales;

So weak, the gilded butterfly scarce perches on my head.

Yet I am visited from heaven, and he that smiles on all.

Walks in the valley, and each morn over me spreads his hand 1:20

Saying, rejoice thou humble grass, thou new-born lilly flower:

Thou gentle maid of silent valleys. and of modest brooks:

For thou shalt be clothed in light, and fed with morning manna;

Till summers heat melts thee beside the fountains and the springs

To flourish in eternal vales; then why should Thel complain, 1:25

 Why

THEL

I

The daughters of Mne Seraphim led round their sunny flocks,
All but the youngest, she in paleness sought the secret air.
To fade away like morning beauty from her mortal day:
Down by the river of Adona her soft voice is heard:
And thus her gentle lamentation falls like morning dew.

O life of this our spring! why fades the lotus of the water?
Why fade these children of the spring? born but to smile & fall.
Ah! Thel is like a watry bow, and like a parting cloud.
Like a reflection in a glass, like shadows in the water,
Like dreams of infants, like a smile upon an infants face,
Like the doves voice, like transient day, like music in the air:
Ah! gentle may I lay me down, and gentle rest my head.
And gentle sleep the sleep of death, and gentle hear the voice
Of him that walketh in the garden in the evening time.

The Lilly of the valley breathing in the humble grass
Answerd the lovely maid and said; I am a watry weed.
And I am very small, and love to dwell in lowly vales;
So weak, the gilded butterfly scarce perches on my head.
Yet I am visited from heaven and he that smiles on all,
Walks in the valley, and each morn over me spreads his hand
Saying, rejoice thou humble grass, thou new born lilly flower,
Thou gentle maid of silent valleys, and of modest brooks;
For thou shalt be clothed in light, and fed with morning manna:
Till summers heat melts thee beside the fountains and the springs
To flourish in eternal vales: then why should Thel complain,

Why

Plate 2

This scene is probably intended to represent the Lilly's farewell to Thel as described in lines 17–18 above it. It is a reverse view of the illustration on plate ii; as on plate ii, some of the flowers are open, but those nearest Thel are closed.

There is considerable variation of detail among the copies. In copy I–1 some green trees have been painted into the background; in copies II–11, II–12, and III–2 the text part of the plate has been colored; in copies II–12 and II–13 there is a framing line; in copy II–12 a light purple cloud surrounds Thel; and in copy II–13 the figures have been outlined in black. The Lilly is consistently colored grayish or bluish white.

Why should the mistress of the vales of Har, utter a sigh.

She ceasd & smil'd in tears, then sat down in her silver shrine.

Thel answerd, O thou little virgin of the peaceful valley.
Giving to those that cannot crave, the voiceless, the o'ertired:
Thy breath doth nourish the innocent lamb, he smells thy milky garments, 2:5
He crops thy flowers, while thou sittest smiling in his face,
Wiping his mild and meekin mouth from all contagious taints.
Thy wine doth purify the golden honey; thy perfume,
Which thou dost scatter on every little blade of grass that springs,
Revives the milked cow, & tames the fire-breathing steed. 2:10
But Thel is like a faint cloud kindled at the rising sun;
I vanish from my pearly throne, and who shall find my place.

Queen of the vales the Lilly answerd, ask the tender cloud,
And it shall tell thee why it glitters in the morning sky,
And why it scatters its bright beauty thro' the humid air. 2:15
Descend O little cloud & hover before the eyes of Thel;

The Cloud descended, and the Lilly bowd her modest head:
And went to mind her numerous charge. among the verdant grass.

Why should the mistress of the vales of Har, utter a sigh.

She ceasd & smild in tears, then sat down in her silver shrine.

Thel answerd. O thou little virgin of the peaceful valley,
Giving to those that cannot crave, the voiceless, the o'ertired
Thy breath doth nourish the innocent lamb, he smells thy milky garments,
He crops thy flowers, while thou sittest smiling in his face,
Wiping his mild and meekin mouth from all contagious taints.
Thy wine doth purify the golden honey, thy perfume,
Which thou dost scatter on every little blade of grass that springs
Revives the milked cow, & tames the fire-breathing steed.
But Thel is like a faint cloud kindled at the rising sun:
I vanish from my pearly throne, and who shall find my place.

Queen of the vales the Lilly answerd, ask the tender cloud,
And it shall tell thee why it glitters in the morning sky,
And why it scatters its bright beauty thro' the humid air.
Descend O little cloud & hover before the eyes of Thel.

The Cloud descended, and the Lilly bowd her modest head:
And went to mind her numerous charge among the verdant grass.

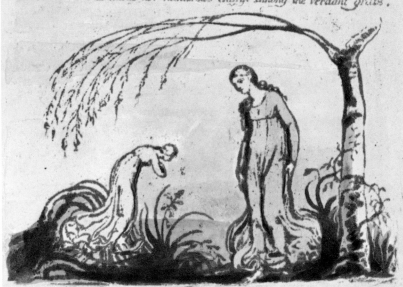

Plate 3

The leafy twig above and the leaf below may be an attempt to link this plate compositionally with the previous ones. The idea of a two-part plate with an "above" and a "below" is suggested by the many copies in which the sky is painted in. In about half the copies color has been added to the text or lower part of the plate.

There is some variation in detail among the copies. In copies I–2 and II–8 some green has been added to the twig; in copies II–5, II–6, II–12, and II–13 the twig and leaf have been outlined in ink; and in copies II–12 and II–13 there is a framing line.

II. *3*

O little Cloud, the virgin said, I charge thee tell to me,
Why thou complainest not when in one hour thou fade away;
Then we shall seek thee but not find; ah Thel is like to thee.
I pass away. yet I complain, and no one hears my voice;

The Cloud then shew'd his golden head & his bright form emerg'd, 3:5
Hovering and glittering on the air before the face of Thel.

O virgin know'st thou not; our steeds drink of the golden springs
Where Luvah doth renew his horses; look'st thou on my youth,
And fearest thou because I vanish and am seen no more.
Nothing remains; O maid I tell thee, when I pass away, 3:10
It is to tenfold life, to love, to peace, and raptures holy;
Unseen descending. weigh my light wings upon balmy flowers:
And court the fair eyed dew, to take me to her shining tent;
The weeping virgin, trembling kneels before the risen sun,
Till we arise link'd in a golden band, and never part; 3:15
But walk united, bearing food to all our tender flowers.

Dost thou O little Cloud? I fear that I am not like thee;
For I walk through the vales of Har, and smell the sweetest flowers;
But I feed not the little flowers: I hear the warbling birds,
But I feed not the warbling birds. they fly and seek their food; 3:20
But Thel delights in these no more because I fade away,
And all shall say, without a use this shining woman liv'd,
Or did she only live. to be at death the food of worms.

The Cloud reclind upon his airy throne and answer'd thus.

Then if thou art the food of worms. O virgin of the skies, 3:25
How great thy use, how great thy blessing; every thing that lives,
Lives not alone, nor for itself: fear not and I will call
The weak worm from its lowly bed, and thou shalt hear its voice.
Come forth worm of the silent valley, to thy pensive queen.

The helpless worm arose, and sat upon the Lillys leaf, 3:30
And the bright Cloud saild on, to find his partner in the vale.

III.

II.

O little Cloud the virgin said, I charge thee tell to me,
Why thou complainest not when in one hour thou fade away:
Then we shall seek thee but not find. ah Thel is like to thee.
I pass away, yet I complain, and no one hears my voice.

The Cloud then shewd his golden head & his bright form emerg'd,
Hovering and glittering on the air before the face of Thel.

O virgin knowist thou not. our steeds drink of the golden springs
Where Luvah doth renew his horses: lookst thou on my youth,
And fearest thou because I vanish and am seen no more.
Nothing remains; O maid I tell thee, when I pass away,
It is to tenfold life, to love, to peace, and raptures holy:
Unseen descending, weigh my light wings upon balmy flowers:
And court the fair eyed dew. to take me to her shining tent;
The weeping virgin, trembling kneels before the risen sun,
Till we arise link'd in a golden band, and never part;
But walk united, bearing food to all our tender flowers

Dost thou O little Cloud? I fear that I am not like thee;
For I walk through the vales of Har. and smell the sweetest flowers;
But I feed not the little flowers: I hear the warbling birds,
But I feed not the warbling birds. they fly and seek their food;
But Thel delights in these no more because I fade away
And all shall say, without a use this shining woman liv'd,
Or did she only live, to be at death the food of worms.

The Cloud reclind upon his airy throne and answerd thus.

Then if thou art the food of worms, O virgin of the skies,
How great thy use, how great thy blessing; every thing that lives,
Lives not alone, nor for itself: fear not and I will call
The weak worm from its lowly bed, and thou shalt hear its voice.
Come forth worm of the silent valley, to thy pensive queen.

The helpless worm arose, and sat upon the Lillys leaf,
And the bright Cloud saild on, to find his partner in the vale.

III.

Plate 4

This scene illustrates the Cloud's introduction of Thel to the Worm and the Cloud's subsequent departure described in the last two lines of plate 3. Like plate 2, this is a reverse view of the illustration of plate ii.

In copy I–1 some trees have been painted into the background; in copy II–11, and possibly copy II–7, some hills have been painted into the background; in copies II–10, II–12, and III–1 a cloud (bright yellow, reddish brown, and grayish greenish yellow, respectively) has been painted into the background; in copies II–7, II–12, and II–13 the text area of the plate has been painted over; in copies II–12 and II–13 there is a framing line (incomplete at the top in copy II–12); and in copy II–13 the figures have been outlined in black.

III.

4

Then Thel astonish'd view'd the Worm upon its dewy bed.

Art thou a Worm? image of weakness, art thou but a Worm?
I see thee like an infant wrapped in the Lillys leaf:
Ah weep not little voice, thou can'st not speak, but thou can'st weep;
Is this a Worm? I see thee lay helpless & naked: weeping,　　　　　　　4:5
And none to answer, none to cherish thee with mothers smiles.

The Clod of Clay heard the Worms voice, & raisd her pitying head;
She bow'd over the weeping infant, and her life exhal'd
In milky fondness, then on Thel she fix'd her humble eyes.

O beauty of the vales of Har. we live not for ourselves,　　　　　　　4:10
Thou seest me the meanest thing, and so I am indeed;
My bosom of itself is cold. and of itself is dark,

　　　　　　　　　　　　　　But

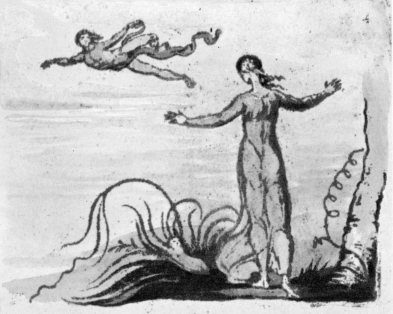

III.

Then Thel astonish'd view'd the Worm upon its dewy bed.

Art thou a Worm? image of weakness. art thou but a Worm?
I see thee like an infant wrapped in the Lillys leaf:
Ah weep not little voice, thou canst not speak. but thou canst weep;
Is this a Worm? I see thee lay helpless & naked: weeping,
And none to answer, none to cherish thee with mothers smiles.

The Clod of Clay heard the Worms voice, & raisd her pitying head;
She bowd over the weeping infant, and her life exhald
In milky fondness, then on Thel she fixd her humble eyes.

O beauty of the vales of Har. we live not for ourselves,
Thou seest me the meanest thing, and so I am indeed;
My bosom of itself is cold. and of itself is dark,

But

Plate 5

The naked girl, or woman, and infant, who suggest the woman and child of plates ii and 1, are probably representations of the Clod and Worm; if so, the scene illustrates Thel's observing the Clod's succoring the Worm on plate 4, lines 7–9. The lily plants are pictorial substitutes for the overspreading branch, providing a frame for Thel and compositionally balancing the outstretched arms of the naked girl, or woman, and infant. A seated figure with bowed head, usually a representation of grief, occurs elsewhere in Blake's designs (cf. especially plates 1, 7, 10, and 11 of *Visions of the Daughters of Albion*).

In copy I–1 hills have been painted into the background; in copies II–12 and III–1 a body of water may have been intended in the background; in copies II–12 and II–13 there is a framing line, and the text of those copies has been painted over; and in copy II–13 the figures have been outlined in black. From copy to copy the flowers have been variously colored pink, blue, purple, light purple, purplish red, strong reddish brown, and light greenish blue; in a given copy they are not always the color that they are on plate ii.

5

But he that loves the lowly, pours his oil upon my head,
And kisses me, and binds his nuptial bands around my breast.
And says; Thou mother of my children, I have loved thee.
And I have given thee a crown that none can take away:
But how this is sweet maid, I know not, and I cannot know, 5:5
I ponder, and I cannot ponder; yet I live and love.

The daughter of beauty wip'd her pitying tears with her white veil,
And said. Alas ! I knew not this, and therefore did I weep;
That God would love a Worm I knew, and punish the evil foot
That wilful, bruis'd its helpless form; but that he cherish'd it 5:10
With milk and oil, I never knew; and therefore did I weep,
And I complain'd in the mild air, because I fade away,
And lay me down in thy cold bed, and leave my shining lot.

Queen of the vales, the matron Clay answerd; I heard thy sighs.
And all thy moans flew o'er my roof, but I have call'd them down: 5:15
Wilt thou O Queen enter my house, 'tis given thee to enter,
And to return; fear nothing. enter with thy virgin feet.

IV

But he that loves the lowly, pours his oil upon my head,
And kisses me, and binds his nuptial bands around my breast,
And says; Thou mother of my children, I have loved thee,
And I have given thee a crown that none can take away.
But how this is sweet maid, I know not, and I cannot know,
I ponder, and I cannot ponder; yet I live and love.

The daughter of beauty wip'd her pitying tears with her white veil,
And said. Alas! I knew not this, and therefore did I weep:
That God would love a Worm I knew, and punish the evil foot
That wilful, bruis'd its helpless form; but that he cherish'd it
With milk and oil I never knew; and therefore did I weep,
And I complaind in the mild air, because I fade away,
And lay me down in thy cold bed, and leave my shining lot.

Queen of the vales, the matron Clay answerd; I heard thy sighs,
And all thy moans flew oer my roof, but I have calld them down:
Wilt thou O Queen enter my house, tis given thee to enter,
And to return; fear nothing, enter with thy virgin feet.

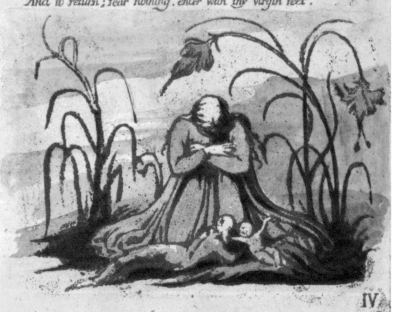

IV

Plate 6

The naked girl, or woman, and the last child are perhaps carried over from the design of plate 5; if so, she and the children represent the Clod and her charges—in more traditional terms, mother earth and her step-children, or humanity. The scene is a pictorial counterpart of the lion and the lamb lying down together and thus is emblematic of peace and good will as found in the vales of Har (see 3:26–27 and 4:10). In Blakean terms the scene also represents the free use of the imagination, or wisdom, and innocent physical love. The curves and coils of the serpent suggest the serpentine stems of the lilies of the previous illustrations, making possible an emblematic association. A similar design appears on plate 11 of *America*, and interestingly both the eagle (see i:1 and the illustration for plate 1) and serpent are given in that work as emblems of Orc—the spirit of freedom, or revolution, on sexual as well as perceptual or imaginative levels.

In copy III–2 three horns have been painted onto the serpent's head; in copies II–7, II–11, II–12, II–13, and III–2 the text area has been colored; in copies II–12 and II–13 there is a framing line; and in copy II–13 the figures are outlined in black.

IV. *6*

The eternal gates terrific porter lifted the northern bar:
Thel enter'd in & saw the secrets of the land unknown:
She saw the couches of the dead, & where the fibrous roots
Of every heart on earth infixes deep its restless twists:
A land of sorrows & of tears where never smile was seen. 6:5

She wander'd in the land of clouds thro' valleys dark, listning
Dolours & lamentations: waiting oft beside a dewy grave
She stood in silence, listning to the voices of the ground,
Till to her own grave plot she came, & there she sat down,
And heard this voice of sorrow breathed from the hollow pit— 6:10

Why cannot the Ear be closed to its own destruction?
Or the glistning Eye to the poison of a smile!
Why are Eyelids stord with arrows ready drawn,
Where a thousand fighting men in ambush lie!
Or an Eye of gifts & graces. show'ring fruits & coined 6:15
 gold!
Why a Tongue impress'd with honey from every wind?
Why an Ear, a whirlpool fierce to draw creations in?
Why a Nostril wide inhaling terror trembling & affright.
Why a tender curb upon the youthful burning boy!
Why a little curtain of flesh on the bed of our desire? 6:20

The Virgin started from her seat, & with a shriek.
Fled back unhinderd till she came into the vales of
 Har.

The End

48

IV.

The eternal gates terrific porter lifted the northern. bar:
Thel enterd in & saw the secrets of the land unknown:
She saw the couches of the dead, & where the fibrous roots
Of every heart on earth infixes deep its restless twists:
A land of sorrows & of tears where never smile was seen.

She wanderd in the land of clouds thro' valleys dark, listning
Dolours & lamentations: waiting oft beside a dewy grave
She stood in silence. listning to the voices of the ground,
Till to her own grave plot she came, & there she sat down.
And heard this voice of sorrow breathed from the hollow pit.

Why cannot the Ear be closed to its own destruction?
Or the glistning Eye to the poison of a smile!
Why are Eyelids stord with arrows ready drawn,
Where a thousand fighting men in ambush lie?
Or an Eye of gifts & graces, showring fruits & coined
 gold!
Why a Tongue impress'd with honey from every wind?
Why an Ear, a whirlpool fierce to draw creations in?
Why a Nostril wide inhaling terror trembling & affright.
Why a tender curb upon the youthful burning boy!
Why a little curtain of flesh on the bed of our desire?

The Virgin started from her seat, & with a shriek.
Fled back unhinderd till she came into the vales of
 Har

The End

Appendixes

Notes

Bibliography

Index

Appendixes

I. EXTANT COPIES PRINTED BY BLAKE

Each of the descriptions below of the known copies of *Thel* printed by Blake has the following information: the equivalent letter symbol of the copy given in the Keynes and Wolf *Census;* whether or not the copy has all eight plates; the color of the ink; the color of the paint used to fill in "*BOOK*" and "THEL" on plate ii, and Thel's dress on plates ii, 2, 4, and 5; the paper company's watermark, if any, and its dimensions and location on the sheet; and the current owner of the copy and/or its whereabouts.

Careful attention has been given to the location and measurement of the watermarks because this information may eventually lead to the discovery of contemporaneous or near-contemporaneous copies of other illuminated works. Although the design of a particular company's watermark remained more or less the same, it varied in size according to the paper size and from lot to lot of paper of the same size because the new mold for the watermark was copied but not traced from its predecessor (see the various works by Dard Hunter on hand-made paper).

At times Blake seems to have purchased paper for printing in lots—for example, the "Ruse & Turners / 1815" paper on which are printed not only copies II–12 and II–13 of *Thel* but also Keynes and Wolf copies N, O, and P of *Visions of the Daughters of Albion,* copy G of *The Marriage of Heaven and Hell,* and copy D of *Milton* (ca. 1804). Comparison of the location and size of the watermarks in the two copies of *Thel,* copy P of *Visions of the Daughters of Albion,* and the copies of the other two works reveals that they are identical; therefore, it is probable that at least some of the paper is from the same lot and that the printing of the copies is more or less contemporaneous. Of course, the contemporaneity of these copies had been surmised on the basis of Blake's technique of coloring, but now scholars can go on to order them by comparing them as to coloring. Perhaps future investigations will uncover copies of illuminated works contemporaneous with copy II–1, which has a "J Whatman" watermark, and copy II–7, which has an "I. Taylor / 1794" watermark.

Since many of the copies were cut for binding, the average page size is about 12 by 9 inches, the smallest copy (II–3) measuring about 10 1/2 by 7 1/5 inches, the largest (II–7) about 14 3/4 by 10 3/4 inches. For further information about page size and provenance, see the Keynes and Wolf *Census.*

KNOWN COPIES

I–1 K. Complete. Yellow green ink; plate i lighter yellow green. "*BOOK*" pale blue. "THEL" pale gray. Dress ii pale yellow; dress 2 yellow brown; dress 4, 5 pale yellow. In Yale University Library.

I–2 R. Complete. Yellow brown ink. "*BOOK*" dark yellow. "THEL" yellowish pink. Dress ii pale greenish yellow; dress 2, 4, 5 greenish yellow. Property of Paul Mellon.

II–1 a. Incomplete proof copy; lacks plates i, 6. Black ink. Uncolored. Watermark "J Whatman" reads from left to right on recto plate ii along right-hand edge near upper corner; 4 1/16 inches from *J* to *n*; *W* 11/16 inch high; *n* 7/16 inch high. In Pierpont Morgan Library.

II–2 C. Complete. Brown ink. "*BOOK*" pink. "THEL" pink. Dress ii pale greenish blue; dress 2 pale bluish green; dress 4 light bluish green; dress 5 bluish green. Property of Mrs. Landon K. Thorne.

II–3 A. Complete. Yellow brown ink. "*BOOK*" pink. "THEL" pale pink. Dress ii, 2, 4, 5 vivid yellow. Property of Mrs. John Butler Swan; on deposit, Harvard College Library.

II–4 B. Complete. Yellow brown ink. "*BOOK*" yellowish pink. "THEL" greenish yellow. Dress ii purplish red; dress 2 pale purplish red; dress 4, 5 purplish red. Property of Paul Mellon.

II–5 D. Complete. Yellow brown ink. "*BOOK*" strong blue. "THEL" strong blue. Dress ii pale blue; dress 2 pale purple; dress 4 pale blue; dress 5 pale purple. In British Museum.

II–6 E. Incomplete; lacks plate i. Faded reddish brown ink; crumbs of green ink on plate 6. "*BOOK*" strong blue. "THEL" greenish yellow. Dress ii, 2, 4, 5 bright pink. In Yale University Library.

II–7 F. Complete. Yellow brown ink. "*BOOK*" uncolored. "THEL" uncolored. Dress ii, 2, 4, 5 vivid yellow. Watermark "I. Taylor" reads from left to right on verso plate 3 along left-hand edge near lower corner; 2 7/8 inches from *I* to *r*; *T* 1 5/8 inches high; *r* 3/8 inch high. Watermark "1794" reads from left to right on recto plate 5 along left-hand edge near upper corner; 1 inch from *1* to *4*; *1*, 1/4 inch high. In Lessing J. Rosenwald Collection, Library of Congress.

II–8 G. Complete. Plate i yellow green ink; plates ii, 1, 2, 3, 6 bluish green ink; plates 4, 5 blue ink. "*BOOK*" dark yellow. "THEL" yellowish pink. Dress ii, 2, 4, 5 light bluish green. In Fitzwilliam Museum, Cambridge University.

II–9 H. Complete. Yellow green ink. "*BOOK*" moderate yellow. "THEL" moderate yellow. Dress ii, 2, 4, 5 green and gray shading. In Lessing J. Rosenwald Collection, Library of Congress.

II–10 L. Complete. Yellow green ink; slightly darker on plate 1. "*BOOK*" uncolored. "THEL" uncolored. Dress ii, 2 light grayish pink; dress 4 pink shading; dress 5 pale red. In Henry E. Huntington Library.

II–11 M. Complete. Orange brown ink. "*BOOK*" yellow green. "THEL" yellow green. Dress ii, 2, 4, 5 light grayish pink. In Henry W. and Albert A. Berg Collection, New York Public Library.

II–12 N. Complete. Reddish brown ink. "*BOOK*" greenish yellow. "THEL" greenish yellow. Dress ii, 2, 4 blue, gray, and greenish yellow shading; dress 5 bright yellow. Watermark "Ruse & Turners / 1815" reads from left to right on verso plate 4 along left-hand edge; 8 1/4 inches from *R* to final *s*; 2 1/4 inches from *1* to *5*; *R* 3/4 inch high; first *u* 9/16 inch high; *8*, 9/16 inch high. Identical watermark reads from left to right on recto plate 6 along left-hand edge. In Cincinnati Art Museum.

II–13 O. Complete. Orange brown ink. "*BOOK*" grayish green. "THEL" grayish green. Dress ii, 2, 4, 5 pink and gray shading. Watermark "Ruse & Turners / 1815" reads from left to right on recto plate 1 along right-hand edge; same dimensions as copy II–12. Identical watermark reads from left to right on verso plate 6 along left-hand edge. In Lessing J. Rosenwald Collection, Library of Congress.

III–1 I. Complete. Dark gray ink. "*BOOK*" uncolored. "THEL" uncolored. Dress ii light grayish pink; dress 2 grayish pink; dress 4 light pink; dress 5 pale purple. In Bodleian Library, Oxford University.

III–2 J. Complete. Yellow green ink. "*BOOK*" greenish yellow except for *B*, which is uncolored. "THEL" uncolored. Dress ii green; dress 2 grayish yellow brown; dress 4 greenish yellow; dress 5 light grayish pink. In Harvard College Library.

CONJECTURAL COPIES

The Keynes and Wolf *Census* lists two other copies—P and Q—but in spite of an advertisement in the *Times Literary Supplement* and a query in *Notes and Queries* I have found no trace of them. In a letter to me dated 18 January 1965 Sir Geoffrey Keynes suggested that these copies might be identified with those be listed as G and H.

There are four other conjectural copies. The first is the original that William Muir claimed to have used for his facsimile edition of 1920. The coloring ("*BOOK*" yellow; "THEL" pink; dress ii green; dress 2 greenish yellow; dress 4 green; dress 5 red) does not match any of the copies described above; but the colors of Muir's 1884 facsimile of copy II–5 are not rendered faithfully, so it is possible that the 1920 facsimile also varies from its original. There are reproduc-

tions of the title page of *Thel* in Swinburne's *William Blake: A Critical Essay*, Benoit's *Un maître de l'art: Blake le visionnaire*, and Garnett's *William Blake: Painter and Poet*. None of these reproductions match any of those listed above. In Swinburne's work, the colors are as follows: "*BOOK*" green; "THEL" green; dress pale blue. The coloring of Benoit's work is similar to copy II–2: "*BOOK*" light grayish pink; "THEL" light grayish pink; dress olive green. In Garnett's work, "*BOOK*" is uncolored, except for *OO*, which is bright yellow; "THEL" is uncolored; and the dress is yellowish green. Plate 6 is also reproduced in Garnett's book, and it would seem that this copy belonged to the third state, since lines 19 and 20 are missing (see Introduction, pp. 4–8). As in copy III–1, crumbs of the expunged letters are visible, but there are no covering decorations.

2. VARIANTS OF PUNCTUATION PRESUMABLY ADDED BY BLAKE BY HAND AND ALTERNATIVE READINGS OF PUNCTUATION

i:1 (pit?) Possibly a normal question mark, but Blake commonly used a question mark over a comma and an exclamation point over a comma (e.g., 6:12). The comma is unusually elongated.

1:1 (flocks.) Possibly a comma in all copies. The visible difference between a period and a comma is often negligible, as here.

1:5 (dew.) Possibly a comma in copies II–1 and II–11.

1:8 (bow.) Possibly a comma in copies I–1, II–1, II–2, II–6, II–8, and II–11.

1:8 (cloud.) Possibly a comma in copy II–1.

1:12 (down,) Period supplied by hand in copy II–9.

1:16 (said;) Semicolon supplied by hand in copies II–4, II–8, III–1, and possibly II–11. Comma supplied by hand in copies II–9 and II–10.

1:19 (all.) Possibly a comma in copy II–3.

1:21 (flower:) Possibly a comma in copies I–1, II–1, II–6, II–8, II–10, and II–11.

1:25 (vales;) Semicolon supplied by hand in copy II–9. Colon supplied by hand in copy II–11.

2:3 (valley.) Possibly a comma in copies I–1, II–1, II–6, and II–11.

2:8 (honey;) Semicolon deduced. Copies I–1, II–1, II–2, II–8, II–10, II–11, II–12, and III–1, and possibly I–2, II–4, II–6, II–7, and II–9, have a comma. Copy II–13 has a colon.

3:1 (said,) Comma supplied by hand in copy III–1.

3:1 (me,) Comma supplied by hand in copy II–11.

3:4 (voice;) Semicolon deduced. Copy II–11 has a comma. Copy II–13 has a colon. All other copies have a period.

3:7 (not;) Semicolon deduced. Comma supplied by hand in copies II–9 and III–1. Copies II–1, II–12, and II–13 have a colon. Copy II–8 has a comma. Copies II–3, II–10, and III–2 have no punctuation. Copies I–1, I–2, II–2, II–4, II–5, II–6, II–7, and II–11 have a period.

3:8 (horses;) Semicolon supplied by hand in copy II–4. Colon supplied by hand in copies II–10 and III–1.

3:9 (more.) Possibly a comma in copies II–1 and II–8.

3:10 (remains;) Semicolon possibly supplied by hand in copy III–1.

3:11 (life,) Comma supplied by hand in copy II–9.

3:11 (love,) Comma supplied by hand in copy II–4.

3:11 (peace,) Comma supplied by hand in copy II–11.

3:11 (holy;) Colon supplied by hand in copy III–1.

3:12 (descending.) Period supplied by hand in copy III–1. Possibly a comma in copies I–1, I–2, II–11, and II–12.

3:12 (flowers:) Possibly a semicolon in copy I–2.

3:13 (dew,) Comma supplied by hand in copy II–9; comma possibly supplied by hand in copy II–4.

3:15 (band,) Comma supplied by hand in copy II–11.

3:19 (birds,) Comma supplied by hand in copy II–11.

3:25 (worms.) Possibly a comma in copies I–1, II–1, II–4, II–6, II–8, II–9, and II–13.

3:29 (queen.) Possibly a solidus in copies I–1 and II–6.

4:1 (bed.) Possibly a colon in copy II–4.

4:10 (ourselves,) Comma supplied by hand in copy II–11.

4:12 (cold.) Possibly a comma in copies II–8 and II–10.

5:14 (sighs.) Possibly a comma in copies I–1, I–2, II–2, II–10, II–11, and II–13.

5:17 (nothing.) Possibly a comma in copy II–1.

6:7 (lamentations:) Possibly an exclamation point in copies II–8, II–9, and II–13.

6:15 (graces.) Possibly a comma in copies I–2, II–1, II–4, II–9, II–10, II–11, II–13, and III–1.

6:21 (shriek.) Possibly a comma in copies II–8 and II–11.

6:22 (Har.) Possibly a comma in copies I–2 and II–8.

Notes

[Shortened references only are given to works in Selected References, pp. 75–79.]

ABBREVIATIONS

A	*America, a Prophecy*
Bryant	Jacob Bryant, *A New System*, 3d ed., 6 vols. (London: J. Walker, 1807)
Darwin	Erasmus Darwin, *The Loves of the Plants*, in *The Botanic Garden* (New York: T. & J. Swords, 1807), pt. 2
FQ	Spenser, *The Faerie Queene*
FR	*The French Revolution*
Hervey	James Hervey, *Meditations and Contemplations* (London: R. Evans, 1818)
J	*Jerusalem*
Los	*The Song of Los*
M	*Milton*
MHH	*The Marriage of Heaven and Hell*
NT	Edward Young, *Night Thoughts*
PL	Milton, *Paradise Lost*
PS	*Poetical Sketches*
VDA	*Visions of the Daughters of Albion*
Wesley	*The Poetical Works of John and Charles Wesley*, G. Osborn, ed., 13 vols. (London: Wesleyan Methodist Conference Office, 1868–72)

INTRODUCTION

1. On the dating of *Tiriel* in relation to Blake's other works, see *Tiriel: Facsimile and Transcript of the Manuscript, Reproduction of the Drawings, and a Commentary on the Poem*, ed. G. E. Bentley, Jr. (Oxford, 1967), pp. 50–51. In "A New Look at Blake's *Tiriel*," *Bulletin of The New York Public Library* 74 (1970):153–65, I suggest that there may be a reference in the poem to the Regency debate, which occurred in December 1788 and January 1789.

2. "Suppressed and Altered Passages in Blake's *Jerusalem*," *SB* 17 (1964):52. According to Erdman, the change from a *g* with a serif on the right side to one with a serif on the left side is reflected in *MHH* (ca. 1790–93), about half the plates displaying the first kind of *g*, and the remaining half the second. It appears that on pl. 7 (that beginning, "—roding fires he wrote the following sentences now per—") both kinds of *g*'s can be found. Erdman disagrees, saying that what I suppose to be an earlier *g* is flawed.

3. In "Thomas Taylor and Blake's Drama of Persephone," pp. 378–94, George Mills Harper claimed a later date for pl. 6 of *Thel* on the basis of the influence of Thomas Taylor's *Dissertation on the Eleusinian and Bacchic Mysteries*, to which the British Museum has assigned 1790 as a tentative date of publication. But Taylor's influence on *Thel* is questionable (see above, p. 16), and the

only notice of his *Dissertation* was in 1794 in the *Analytical Review*, whose reviews of Taylor's other works generally appeared within a year of publication.

4. This probably indicates an improvement in Blake's technique of transferring text to plate rather than wear from use. Indications that the printed page was retouched are plainly visible on pl. 1 of copies I–2, II–2, II–4, II–8, II–10, II–11, II–13, and III–1; on pl. 2 of copies II–8, II–13, and III–1; and on pl. 3 of copies II–4, II–6, II–8, II–9, II–11, II–13, and III–1. Blake undoubtedly retouched the printed page of pls. 4, 5, and 6, too, but except for a slight indication on pl. 5 of copy II–13, I have not discovered any signs of it.

5. The Clod of Clay's speech to Thel at the end of pl. 5 would seem to indicate that something other than the present version of pl. 6 originally followed it. A well-meaning creature, the Clod invites Thel to enter her house, telling her to "fear nothing" and leading Thel (and the reader) to believe that she will be able to return to Har with no trouble. Thel does return "unhindered," but she first experiences a shock and shrieks.

6. The watermark date "1794" is misleading; the paper may have been manufactured much later. In 1794 a law requiring the dating of English paper was passed, and although manufacturers generally complied, they often did not re-date a particular size of paper until the watermark mold was so worn that a new mold had to be made. The makers of Whatman paper offer a good example. According to Erdman in *Blake: Prophet against Empire* (p. 292, n. 20), the only dated paper issued by the Whatman firm before 1800 bore the date "1794."

7. See Blake to Dawson Turner, 9 June 1818, and Blake to George Cumberland, 12 Apr. 1827 (Keynes, *Letters*, pp. 139, 162); see also Erdman, *Poetry and Prose*, pp. 670–71.

8. One set is in the Pierpont Morgan Library, another in the British Museum.

9. Since the designs are in brown ink or paint, and crumbs of ink that are the same color as the lines above show through the designs, Blake apparently added the designs by hand.

10. Copies II–1 (see ill., p. 6) and II–2 reflect the change from *gently* to *gentle*, since the *y* and *e* are both visible in those copies. The loop of the *e* appears to have been formed by joining the two arms of the *y*; the *e* is darker than the *y*.

11. E.g., *MHH* 10:66 (p. 37).

12. Attempts, possibly open to question, are made to pursue this idea in Bottrall, *The Divine Image*, and E. D. Hirsch, Jr., "The Two Blakes," *RES*, n.s. 12 (1961):373–90.

13. For a discussion of Blake's probable method of inking his relief-etched copper plates and a demonstration of how the printing of a canceled plate fragment of *America* resulted in a poor impression of punctuation marks, see Ruthven Todd, "The Techniques of William Blake's Illuminated P[r]inting," *Print Collector's*

Quarterly 29 (1948):25–36, esp. figs. 3 and 4. Another impression from the same fragment is on file in the Rosenwald Collection. Todd believes that Blake may have deleted marks on his copper plates by painting through them with acid. For a discussion of how Blake may have revised his copper plates by cutting away or gouging out marks, see Erdman, "Blake's Jerusalem."

14. These being generic terms, I use them to refer to Blake's long line with extreme reluctance. I prefer the term *fourteener* to *iambic septenary* (heptameter), which was sometimes called a seven-footed alexandrine in Blake's day.

15. I find two other fourteen- (or possibly fifteen-) syllable lines in *King Edward the Third:* 1. 13 (p. 415) and 3. 274 (p. 424); there are about six thirteen-syllable lines.

16. For a competent, up-to-date summary of scholarly opinion, see Ostriker, *Vision and Verse in William Blake.* I take issue with Miss Ostriker and others before her concerning Blake's debt to Milton. It hardly seems likely that Blake's long line resulted from his "stretching" Milton's pentameter, as she and others have claimed; the two lines are quite different. As for matters like inversions, substitutions, etc., Blake may have learned how to use them from poets other than Milton, e.g., from imitators.

17. See *Windows of the Morning: A Critical Study of William Blake's* Poetical Sketches, *1783* (New Haven: Yale University Press, 1940), p. 171.

18. For more on this, see relevant textual notes; e.g., n. 1:8.

19. *Lectures on the Sacred Poetry of the Hebrews,* 2 vols. (London: J. Johnson, 1787), 1:64, 2:440.

20. Ibid., 1:295. Lowth also made a complete translation of Isaiah, which was published in 1779.

21. Lowth's lectures originally appeared in the 1740s in Latin; Johnson brought out the first English translation.

22. This was the 1616 edition. In "Blake's Library," *TLS* 6 November 1959, p. 648, Geoffrey Keynes noted a receipt for this copy, which was sold by Blake's wife to John Linnell in 1829, but there is no indication of when Blake acquired it.

23. For more on the Wesleyan influence on Blake, see Gleckner, "Blake and Wesley," *N&Q,* n.s. 3 (1956):522–24, and Martha England and John Sparrow, *Hymns Unbidden* (New York: New York Public Library, 1966), pp. 44–112.

24. *History of English Poetry,* 4 vols. (London: J. Dodsley, 1774–81), 3:176.

25. See Erik Routley, *The Music of Christian Hymnody* (London: Independent Press, 1957), p. 37.

26. Blake would not have been unique in using psalm tunes for his verse. In *Poems on Affairs of State: Augustan Satirical Verse, 1660–1714,* ed. George de Forest Lord (New Haven: Yale University Press, 1963–), 2:119–20, there is a poem entitled "A Psalm" that was supposed to be sung "to the tune of the fourth psalm"; the first verse goes,

R. H., they say, is gone to see
The Prince that's at the Hague;
But Portsmouth's left behind to be
The nation's whorish plague.

27. Thomas Sternhold et al., *The Whole Book of Psalms* (London: J. Roberts, 1744).

28. Swinburne (*William Blake*, 1868) and Henry G. Hewlett ("Imperfect Genius," 1876) dealt with the poem earlier than 1893, but they tended to regard it as an allegory and so were primarily concerned with its theme or message. To Swinburne, the poem signified Blake's attempt to "comfort life through death; to assuage by spiritual hope the fleshly fear of man" (p. 200). According to Hewlett, *Thel* showed the "yearning of the human spirit for the solution of the riddle of its destiny," and Blake's theme was "that while all other animate and inanimate things," like the Lilly, Cloud, and Clod, are "happy in the conscious discharge of their earthly function," man—so the voice from the grave informs Thel—"suffers from the perversion of his senses by some tyrannical agency" (p. 780).

29. See Damon, *William Blake*, pp. 74–76, and Frye, *Fearful Symmetry*, pp. 232–35. The latter gives the interpretation breadth by suggesting that Thel "could be any form of embryonic life, from a human baby to an artist's inspiration, and her tragedy could be anything from a miscarriage to a lost vision" (p. 233).

30. "Thomas Taylor and Blake's Drama of Persephone," pp. 378–94. Raine reached similar conclusions at about the same time; see "The Little Girl Lost and Found and the Lapsed Soul." She more or less continues to support this view in *Blake and Tradition*, adding that the theme of the poem is a "debate between the Neoplatonic and alchemical philosophies" (p. 99).

31. The two other works were translations of the hymns of Orpheus (1787) and Porphyry's treatise on Homer's Cave of the Nymphs (1788). As indicated in n. 3, there is a possible problem of chronology in respect to a connection between *Thel* and Taylor's *Dissertation*.

32. *The Life of William Blake*, p. 34.

33. *William Blake: The Politics of Vision*, p. 201. Harper, in "Blake's Drama," pp. 381, 384, came to a similar conclusion, claiming that although Blake was as antimaterialistic as Taylor, he did not share his antipathy to sex.

34. *Valley of Vision*, pp. 205–6.

35. *William Blake: Poet and Mystic*, pp. 326–28.

36. *An Introduction to the Study of Blake*, pp. 87, 92.

37. *Blake's Apocalypse*, pp. 53, 61.

38. *William Blake*, pp. 55–56.

39. *The Piper and the Bard*, pp. 161–74. Gleckner concludes, referring to Thel's

flight: "And before the silver shrine of the lily can be the resting place of the soul, the bed of our desire must witness untrammeled senses in infinite creation, for 'the soul of sweet delight can never be defil'd' " (p. 170).

40. Blake to Thomas Butts, 22 Nov. 1802 (Keynes, *Letters,* p. 61).

41. For more on the literary traditions, see Damon, *A Blake Dictionary* and esp. Gleckner, "*Thel* and the Bible," and Raine, *Blake and Tradition.*

42. *The Shepherd's Calendar,* "November," l. 73.

43. Andrew Lang points this out with regard to the youngest child in fairy tales in his introduction to *Perrault's Popular Tales* (Oxford: Clarendon Press, 1888), p. xcvi.

44. See Bogen, "Blake's *Tiriel.*"

45. Thel may well symbolize the fourth element, fire; for more on this, see n. 1:8.

46. The use of "down by" with "river" is, I realize, idiomatic; but just as Blake used spatial arrangements purposefully in such works as his illustrations to the Book of Job, he may also have done so in *Thel.*

47. Blake's interest in the moon and moon-dwelling about this time is indicated by the setting of *An Island in the Moon.* Moon-dwelling was, of course, a popular literary topic in England in the eighteenth century, as Marjorie Nicolson's *Voyages to the Moon* (New York: Macmillan Co., 1948) reveals.

48. Curiously, there is a similarity between the title page of *Thel* and a depiction of this scene in a contemporaneous edition of *Pilgrim's Progress* (London: Valance and Simmons, 1778).

49. Blake drew and engraved the illustrations for this work. Some verbal parallels with *Thel* have already been noted by Adlard in "Blake and Thomas Taylor," pp. 353–54.

50. (London: George Routledge and Sons, 1867), p. 182.

51. Ibid., p. 69.

52. (London: J. Johnson, 1788), pp. 4, 11.

53. The term "Graveyard School" is misleading, since most of the writers associated with it were clergymen whose aims were to save their friends from everlasting death and damnation by teaching them how to employ their time properly, e.g., in prayer and charity.

54. In view of Thel's talkativeness in the first three parts of the poem, her silence throughout this one is notable. Quite possibly Blake had in mind the English folk tradition that a visitor to the otherworld is prohibited from speaking to its inhabitants; see Lowry Charles Wimberly, *Folklore in the English and Scottish Ballads* (Chicago: University of Chicago Press, 1928), p. 281.

55. This seems to be the poem's only allusion to Neoplatonic doctrine. But did Blake really believe that souls descend into bodies from a realm of spirit? It is doubtful that he did, at least about the time when *Thel* was composed; for in

MHH 4 (p. 34) Blake declares that it is an error to say that "Man has two real existing principles Viz: a Body & a Soul" and that it is true that "Man has no Body distinct from his Soul." Thel's descent from Mne Seraphim, then, seems to be simply poetic fiction.

56. One may wonder how Thel is able to talk so soon after birth; one explanation is a telescoping of the action. A passage of time is suggested by the change of tense in the first stanza from the past (the daughters "led" their flocks; Thel "sought" the air) to the present (her voice "is heard"; her lamentation "falls").

57. An objection may be raised to this idea because Thel calls herself a "woman" on 3:22. But the reference seems to be to the future: "And all *shall* say, without a use this shining woman liv'd" (italics added).

58. Although Blake was no predestinarian and made it clear that prophecy was not a matter of prognostication, he did use the idea of one's having a lot, perhaps as in Jer. 13:25, where it means the logical outcome of a course of action. Not only does *lot* appear quite often in Blake's early works, but the idea of being shown one's lot figures as a literary device in *MHH* 17–20 (pp. 39–41), where Blake and a self-righteous angel show each other their "eternal" lots. Cf. also Blake to John Flaxman, 12 Sept. 1800 (Keynes, *Letters*, p. 38) in which Blake speaks of his own "lot upon Earth" and "lot in the Heavens."

59. Previously noted by Bloom, *Blake's Apocalypse*, p. 58.

60. Blake to Butts, 22 Nov. 1802 (Keynes, *Letters*, p. 62).

61. Although the rod and bowl are not sexual symbols (like the veil carried by Hymen, traditionally symbolizing the maidenhead), many have assumed that they are. But the answer to Blake's question about the rod and bowl is clearly no; and to call them sexual symbols would be tantamount to saying that Blake was contradicting here what he elsewhere said explicitly and figuratively—that he was in favor of sexual freedom. For more on the symbolism of the rod and bowl, see n. i:3–4.

62. *Los* 6:19 (p. 67).

TEXT

i:1, 2 (Eagle, Mole). Traditionally associated with keen and defective vision, respectively. Probably symbolic of double vision and "Single vision," or "Newton's sleep" (see above pp. 19–20, 30–31). In the eighteenth century used to indicate differences in vision in a figurative sense; e.g., "I am quite a mole when compared with these eagle-eyed divines" (John Newton, *Cardiphonia*, in *Works*, 8 vols. [Philadelphia: W. Young, 1839], 1:376). In *MHH* 9:54 (p. 37) the eagle is a "portion of genius"; cf. also *VDA* 5:39–40 (p. 40), where reference is made to

another tradition related to the eagle. An eagle is depicted in *Thel*, pl. 1.

i:1 (pit). Denotes the grave and hell in the Bible; e.g., Isa. 14:15, Job 33:18.

i:3–4 (silver rod, golden bowl). Blake's use of *rod* in other early works and his ideas about wisdom and love ca. 1789 suggest that J. P. R. Wallis's interpretation (*Cambridge History of English Literature* 11:186–87) is the most valid: the silver rod of "authority" and the golden bowl of a "restrictive ethic" are symbols of the "tyranny of the abstract moral law," which is the source of the "degradation" of the "land unknown" of *Thel*, part four. Cf. also *Samson* (p. 436) and *VDA* 5:25 (p. 48), where the rod is a symbol of social and political punishment and oppression; and *MHH* 8:32 (p. 36), where it is more or less the equivalent of false wisdom. Elsewhere in *MHH* Blake indicated that true wisdom and love can only be attained without restraint; e.g., "The road of excess leads to the palace of wisdom" and "He who desires but acts not, breeds pestilence" (p. 35). The usual agents of restraint are law and religion or kings and priests; in *Tiriel* 8:9 (p. 281) they are the "wisdom" of Tiriel, a tyrant prince, and the "laws" of Har, possibly Tiriel's concept of God. (*Thel* i:3–4 occurred here in *Tiriel* as the eighth of twelve lines that were deleted, presumably when Blake transferred the line to *Thel*.) Although Blake's use of *silver* and *gold* was rather casual, the "silver rod" and "golden bowl" may well refer to specific objects connected with state and church; i.e., the staff (generally of "white wood, sometimes of ebony or silver," according to the *OED*) borne by many officials of the crown during the eighteenth century and the golden chalice used for the celebration of the Eucharist in the Church of England. Blake referred to staffs of this kind as "wands as white as snow" in *Holy Thursday*, l. 3 (p. 13), and as "ivory staff" and "ivory wand" in *FR* 144, 198 (pp. 289, 291). Wordsworth called them "silver wands" in *The Prelude* 10. 485 (1850); Coleridge's reference about this time to "mitred Atheism" that "drank iniquity in cups of gold" is significant (*Religious Musings*, ll. 334, 325); see *M* 38:23–36 (p. 138) for a similar reference. For the use of *bowl* in connection with the Eucharist, see Wesley 1:113. Other interpretations can be found in Ellis, *The Real Blake*, p. 156; Damon, *William Blake*, p. 310; Plowman, *Introduction to Blake*, p. 89; Harper, "Thomas Taylor and Blake's Drama of Persephone," p. 385; Anderson, *The American Henry James*, p. 224; Gleckner, *Piper*, pp. 161–62; and Tolley, "*The Book of Thel* and *Night Thoughts*," pp. 375–85.

i:3. Cf. Job 28:12–20.

1:1 (Mne Seraphim). There are indications that Mne Seraphim is a realm of spirit and distinct from the vales of Har (see above pp. 23–24). *Bne Seraphim* ("sons of the Seraphim") occurs in a list of planetary influences in *The Conjuror's Magazine* of 1792 (see Perugini, "An Eighteenth-Century Occult Magazine," pp. 86–89). The same list may be in a similar periodical of an earlier date, or Blake may have found it in Cornelius Agrippa's *Occult Philosophy* (see Damon,

William Blake, p. 310). Perhaps Blake found *Mne* in Bryant, where it occurs as the first syllable of a number of antique names, e.g., Mneuis and Mneuas. According to Bryant (3:62, 290), *Mn* is a contraction of *Men*, a word in the language of the first civilization after the Flood, and originally meant "moon" (*mēnē* is Greek for "moon"). Two other explanations of *Mne*—that it is an anagram of the English word *men* and that it is intended to suggest Mnemosyne, Greek goddess of memory—do not seem as successful; see Wicksteed, *Blake's Innocence and Experience*, p. 132, and Hagstrum, *William Blake, Poet and Painter*, p. 87 n.

1:2 (paleness). Those who are fading, or passing away, are traditionally spoken of as "pale"; e.g., Shakespeare, *A Midsummer-Night's Dream* 1. 1. 128–29, and *Romeo and Juliet* 4. 1. 99–100. Man is sometimes referred to as "pale" in Wesley (e.g., 6:313)—that is, in comparison with Jesus, who walks in light.

1:2 (secret air). In the Old Testament, *secret* is frequently found with *place* and associated with darkness and sometimes danger; e.g., Pss. 17:12, 18:11. The Wesleys called the atmosphere of Earth the "lower air" (e.g., 5:349) and "tainted air" (e.g., 2:83) to distinguish it from the upper air of heaven and heaven's pure air.

1:3. The double analogy of man's life with that of a plant or flower and the daily course of the sun is a commonplace, going back to Theocritus and the Old Testament (e.g., Ps. 90:5–6). Exceedingly popular in the eighteenth century, it was used by Blake himself earlier in his career (cf. *PS*, p. 403, and "Woe cried the muse," p. 439). Significantly, the spiritual was spoken of in related terms; e.g., heaven's "never-fading bliss" (Jacob Duché, *Discourses on Various Subjects*, 2 vols. [London: T. Cadell, 1790], 1:178), and "sweet immortal morning" (Isaac Watts, *The Poems of Isaac Watts . . .*, 2 vols. [Chiswick: C. Whittingham, 1822], 1:132).

1:4 (river of Adona). Possibly a boundary between the spiritual realm of Mne Seraphim and the vales of Har or Earth (see above, pp. 23–24). Other explanations occur in Damon, *William Blake*, p. 310, and Harper, "Thomas Taylor and Blake's Drama of Persephone," p. 386. As Harper has conjectured, Adona conceivably may have been suggested by Eridanus, the name of the river that flows through Virgil's Elysian fields. Bryant noted that Eridanus was "compounded out of Ur-Adon" and added that this name "simply, and out of composition, was Adon or Adonis" (2:174). There is, however, a seraph named Adona in Klopstock's *Messiah* (1763 English translation); as Damon has pointed out (*William Blake*, p. 310), Adonis is the name of a youth mourned for in the Greek mysteries and a river in *PL* 1. 450; it is also the famous earthly paradise of *FQ* 3. The latter is called the "First seminarie / Of all things that are born to live and die" (3. 6. 30).

1:6–11. That all things are born only to die was a familiar theme of English religious writers, particularly those of the "Graveyard School" and the Wesleys. But the passage is similar in outline to hymn 13 of Mrs. Barbauld's *Hymns in Prose for Children* (London: J. Murray, 1781), which features a lament by a "child of

mortality." The child begins the lament concerned for the fate of a flower—albeit a rose, not a lotus—and ends concerned for the fate of man. The conclusion —"And therefore do I weep"—is perhaps echoed in Thel's complaint (5:11–13).

1:6 (lotus of the water). *Lotus* has been used to signify a number of different plants; and some of these, e.g., the Egyptian lotus (*Nymphaea lotus*), have been associated with water. They have sometimes been called water lilies, which Blake may have learned from Darwin, 1789 (p. 208); William Jones's translation of *Sacontala*, 1789 (in *Works*, 13 vols. [London: J. Stockdale and J. Walker, 1802], 9:420–21); Richard Payne Knight's *Discourse on the Worship of Priapus*, 1786 (in *Sexual Symbolism: A History of Phallic Worship* [New York: Matrix House, 1966], pp. 97–99); and probably other works as well. Presumably, then, Blake's lotus is to be identified with the Lilly below, who calls herself a "watry weed."

1:7 (fall). Figuratively, to die, usually suddenly or violently. The idea of being *felled* by a stroke of God was a common theme in eighteenth-century literature; e.g., the history of Celadon and Amelia in James Thomson's *Summer*, ll. 1171 ff. In addition to the season of the year, with its implication of forthcoming death, *fall* here calls to mind the transgression of Adam and Eve, traditionally considered the cause of the death of all things. Plays on the words *fall* and *spring* are quite common in English literature from the Elizabethan period onward; e.g., "Soon your spring must have a fall; / Loosing [*sic*] youth, is losing all" (Joseph Ritson, *Select Collection of English Songs*, 3 vols. [London: J. Johnson, 1783], 2:19).

1:8 (Thel). Perhaps derived from Bryant, where one finds the two supposedly ancient words *ath* and *el*, and the following explanation concerning their combination: "The Egyptians had many subordinate Deities, which they esteemed as so many emanations . . . from their chief God. . . . These derivatives they called fountains, and supposed them to be derived from the Sun; whom they looked upon as the source of all things. Hence they formed Ath-El and Ath-Ain, the Athela and Athena of the Greeks. These were two titles appropriated to the same personage, Divine Wisdom; who was supposed to spring from the head of her father" (1:63). This source is particularly appealing when one realizes that Thel is a human being (see 3:22–23) and, according to Christian tradition, possessed of a soul, or a spark of the divine fire. The usual explanation is that Thel's name is an anagram of Lethe, the river of forgetfulness in Greek legend (see Schorer, *Politics of Vision*, p. 202, and Harper, "Thomas Taylor and Blake's Drama of Persephone," p. 386). Less likely is the possibility that Thel's name was derived from a Greek or Hebrew word (see Damon, *William Blake*, p. 310; Fisher, *Valley of Vision*, p. 205; and Hewlett, "Imperfect Genius," p. 779); for Blake does not appear to have begun learning Greek and Hebrew until about 1800 (see Blake to James Blake, 30 Jan. 1803, Keynes, *Letters*, p. 65). Raine's idea in *Blake and Tradition*, p. 114, that Thel's name was suggested by the name Thalia (*thallein*, "blossoming" or "blossoming one") is an interesting possibility.

1:8 (watry bow). Reminiscent of "humid bow," a phrase used by Milton (e.g., *PL* 4. 151), and "showery bow," used in Wesley (e.g., 5:186). Analogies with man's life, such as the evanescent quality of the rainbow, "parting cloud," "shadows," and "music in the air" below, are quite common in eighteenth-century religious literature; e.g., Hervey, pp. 47, 160; Henry Venn, *The Complete Duty of Man . . .* , 5th ed. (London: W. Baynes, 1803), p. 25; Elizabeth Rowe, *Devout Exercises of the Heart . . .* (Derby, 1826), pp. 110–11.

1:8 (parting cloud). Cf. Job 7:9–10, Hos. 13:3, and James 4:14.

1:9 (shadows). Cf. 1 Chron. 29:15, Job 14:1–2, Eccles. 8:13, and Pss. 102:11, 144:4.

1:10 (dreams). Cf. Job 20:8, and Shakespeare, *The Tempest* 4. 1. 157.

1:11 (doves voice). Probably a reference to the turtle dove whose voice is heard after the winter is past in Song of Sol. 2:11–14. But the dove's voice is short lived, meaning perhaps that winter will come again.

1:11 (transient day). See n. 1:3. Like many words and phrases below (e.g., "clothed in light," fed with "manna," "pensive," "clod," "contagious taints," "pit," "worm," "couches of the dead," "fibrous roots," "gifts & graces," etc.), the word *transient* pervaded the works of Methodist and evangelical writers like William Law, William Romaine, Henry Venn, John Newton, James Hervey, and the Wesleys; *transient* was used also by dissenting figures like Isaac Watts and Mrs. Barbauld, but, seemingly, to a lesser extent.

1:12–13 (Ah! . . . death). A similar sentiment, similarly phrased, pervades the religious writing of eighteenth-century England. Cf. *NT* 9. 2321–26:

> In Thy displeasure dwells eternal pain;
> Pain, our aversion; pain, which strikes me now;
> And, since all pain is terrible to man,
> Though transient, terrible; at Thy good hour,
> Gently, ah, gently, lay me in my bed,
> My clay-cold bed! by nature, now, so near.

Also, Wesley 5:118:

> O that I my wish might have,
> Quietly lay down my head,
> Sink into an early grave,
> Now be number'd with the dead.

1:13–14 (hear . . . time). Probably a reference to God's "walking in the garden in the cool of the day" after the Fall (Gen. 3:8). The phrase "evening time" may also refer to the close of Thel's "mortal day" (see n. 1:3); and perhaps a pun was intended on Eve's time, i.e., the moment of the Fall. Thel seems to be longing for an experience with God similar to that anticipated by the Little Black Boy:

we shall hear his voice.
Saying: come out from the grove my love & care,
And round my golden tent like lambs rejoice.

[ll. 18–19, p. 9]

1:15 (Lilly of the valley). Probably a composite of several different varieties: the lily of the valley (*Convallaria majalis*); a water lily (see n. 1:6); and possibly the ordinary garden lily (genus *Lilium*) or the pasqueflower (*Anemone pulsatilla*); see illustrations, *Thel* ii, 2, and 5, and Raine, *Blake and Tradition*, p. 105. Raine makes a case for the pasqueflower, which can be purple or red; but Blake used a very wide range of colors for this flower. Hervey, p. 103, identified the lily of the valleys of Song of Sol. 2:1 with Christ, as is traditional, but also voiced the untraditional opinion that the garden lily is referred to there, not *Convallaria majalis*. The lily also symbolizes purity of mind and body; in 2 Esdras 5:25, the Lord is said to have chosen it above all other flowers. But unlike Christ's lilies of the field in Matt. 6:28, Blake's flower leads an exceedingly active life (see 2:4–10). Blake emphasized the Lilly's youth, modesty, and humbleness (e.g., 1:21, 2:3, 2:17). In *The Lilly* of *Songs of Experience* she represents a modesty and humbleness of a higher order than that of the rose and sheep (p. 25).

1:15 (humble grass). Reminiscent of Milton's "humble shrub and bush" in *PL* 7. 322–23, and the flower's "humble bed" in Pope, *The Dunciad*, 4. 405.

1:16 (watry weed). I.e., she dwells in or near water and is mortal; cf. *FQ* 3. 2. 45. 4: "He faded to a watry floure."

1:18 (gilded butterfly). Cf. Shakespeare, *Coriolanus* 1. 3. 66 and *King Lear* 5. 3. 13.

1:23. According to Christian tradition, those who keep faith with God will receive white garments (Rev. 3:5); and Christ, who is clothed in light himself (Ps. 104:2), will give light to the faithful (Eph. 5:14), who will also be fed with "hidden manna" (Rev. 2:17). Cf. also Exod. 16:19–21, in which manna melts from the sun's heat in the morning.

2:1 (vales of Har). Apparently an earthly paradise (see above, pp. 22–23). The possible sources for *Har* are associated with heaven and earth. In Bryant it means "mountain" and according to him survives in place names like Ararat and Armenia (4:1–17 pass.). (*Har* is Hebrew for "mountain," but see n. 1:8.) In Thomas Percy's translation of Mallet's *Northern Antiquities* (1770), *Har* is the name of a god; there is a god named *Hara* in Jones's translation of *Sacontala* (1789).

2:2 (shrine). According to the *OED*, "a receptacle containing an object of religious veneration; occas. a niche for sacred images" (e.g., the "silver shrines for Diana" in Acts 19:24); also, "that which encloses, enshrines, or screens, or in which something dwells" (e.g., the flower ocyma's "crystal shrine" in Darwin, p. 211). Cf. also *VDA* 1:10 (p. 45).

2:4–12. Cf. *NT* 3. 24–34:

Queen lilies! and ye painted populace!
Who dwell in fields, and lead ambrosial lives;
In morn and evening dew your beauties bathe,
And drink the sun; which gives your cheeks to glow,
And out-blush (mine excepted) every fair;
You gladlier grew, ambitious of her hand,
White often cropp'd your odours, incense meet
To thought so pure! Ye lovely fugitives!
Coeval race with man! for man you smile;
Why not smile at him too? You share indeed
His sudden pass; but not his constant pain.

2:4 (o'ertired). In all the printed copies of *Thel* this word reads "o'erfired." Evidently a misprint, since the only usage for this word listed by the *OED* is in the context of metallurgy or ceramics; e.g., "Gold might be made but the Alchymists over-fired the Work" (Bacon, *Sylva*). Still, it is tempting to speculate that Blake intended the word to be "o'erfired," inventing a new meaning—the fire-breathing, or enraged, animal.

2:7 (meekin). Either a corruption of *meekened* (past participle of *to meeken*) or of *meeking* (present participle of *to meek*); both have the meaning of "to become meek." In the eighteenth century James Thomson and the Wesleys used *to meeken* extensively (e.g., Thomson, *Spring*, ll. 265, 944).

2:11–12. Cf. Job 7:9.

2:18 (verdant grass). Spenser used this phrase a good deal (e.g., *FQ* 1.9.13.3); tufts of grass are visible in the illustrations to pls. 2, 4, 5, and 6.

3:2–4. Similarly, Hervey spoke of the dew as "short-lived ornaments, possessed of little more than a momentary radiance. The sun, that lights them up, will soon melt them into air, or exhale them into vapours. Within an hour we may 'look for their place, and they shall be away'" (p. 78).

3:3 (we . . . find). Cf. Prov. 1:28, Isa. 41:12, and John 7:33–34.

3:8 (Luvah). Possibly a representation of the natural moon as opposed to the spiritual one of Mne Seraphim (see n. 1:1); also possibly day or dawn, if the "golden springs" shared by the Cloud's steeds and Luvah's horses refer to their common source of light. A less likely possibility is that Luvah is connected with the sun (see Sloss and Wallis, *The Prophetic Writings*, 2:272 n.), since the sun is mentioned in 3:14. Also, although steeds are traditionally associated with the sun, elsewhere in Blake's work Luvah is depicted with bulls (e.g., *M* 21:20, p. 114), which are traditionally associated with the moon, as Blake could have learned from Bryant. Perhaps *Luvah* was suggested by names for the moon in Bryant, 3:318–26: Laban, Liban, Libanah, Lavana, Luna, Lubentia, Lubentina, Luban, Labar, and Lubar. There is a stream named Lubar in Macpherson's Ossian and a goddess named Lovna in Mallet's *Northern Antiquities*; and, as has

often been said, Blake may have intended to suggest by it *lover* or *love*. Luvah is referred to as the "prince of Love" in later works, e.g., *FZ* 12:14 (p. 302).

3:11 (tenfold). Unlike other numerical designations in Blake's works, like the number four in *M* and *J*, this one seems to have no real or symbolical significance. It was occasionally used in the same way by Milton (e.g., *PL* 2. 705), and the Wesleys used it frequently in their hymns (e.g., 4:46).

3:12–16. This tenderly erotic courtship is reminiscent of many of the descriptions of pollination in Darwin, e.g., p. 41. The scene seems to be depicted on pl. ii of *Thel*: a naked man in flight, resembling the representation of the Cloud on pl. 4, grasps a woman, the "fair eyed dew," around the waist as if to embrace her. The woman's arms are raised in joy.

3:23. Cf. Job 19:26, 21:26, 24:20.

3:26–27 (every . . . itself). Also expressed by the Clod below (4:10) and by the Clod in *The Clod and the Pebble* (p. 19).

4:3. I.e., as if wrapped in swaddling clothes; cf. Luke 2:7.

4:9 (milky fondness). Reminiscent of Shakespeare's "milk of human kindness" in *Macbeth* I. 5. 18, and Pope's "milky mothers" in *The Dunciad* 2. 247.

5:4. Cf. 1 Pet. 5:4 and Rev. 3:11.

5:5–6. Hervey's vision was, by his own admission, similarly limited: "I gaze, I ponder; I ponder, I gaze, and think ineffable things.—I roll an eye of awe and admiration. Again and again, I repeat my ravished views, and can never satiate either my curiosity, or my inquiry. I spring my thoughts into this immense field till even fancy tires upon her wind. I find wonders ever new; wonders more and more amazing.—Yet, after all my present inquiries, what a mere nothing do I know. . . . Could I pry with Newton's piercing sagacity, or launch into his extensive surveys; even then, my apprehensions would be little better than those dim and scanty images which the mole, just emmerged from her cavern, receives on her feeble optic" (p. 340).

5:9–10 (That . . . form). Representative of the eighteenth-century movement that has been called "sentimental morality."

5:14–15 (I . . . down). Cf. 2 Kings 20:5 and Isa. 38:5.

6:1–22. This plate differs from plates 1 through 5 to such a degree as to suggest the possibility that the poem originally had another ending. For more on this, see above, p. 3.

6:1 (porter). A porter at the gate, frequently a fearsome one, is a familiar figure in depictions of the world of evil spirits, to which *Paradise Lost* and the *Inferno* testify. Thus, attempts like those of Harper in "Thomas Taylor and Blake's Drama of Persephone," p. 381, and Raine in *Blake and Tradition*, pp. 100–101, to link this porter with a specific or traditional literary one (i.e., Pluto of Porphyry's *To Pluto* and Spenser's Genius) seem futile.

6:1 (northern bar). In England and on the Continent, the north, ice, and cold

are traditionally associated with the region of evil spirits; see Lowry Charles Wimberly, *Folklore in English and Scottish Ballads* (Chicago: University of Chicago Press, 1928), pp. 136 ff. Milton and Dante included cold and ice in their hells; in Jeremiah (e.g., 4:6) there is constant reference to "evil" from the "north," and Blake's use of *north* and *ice* in other early works conforms to this tradition: Gwin, a tyrant prince, rules over the north (*Gwin* l. 3, p. 409); Tiriel, another tyrant, claims to come from there (*Tiriel* 2:44–45, p. 275); and the malign Urizen is often depicted with snow (e.g., *A* 16:5, p. 56). In later works the north is the place of the Imagination; and the Eternals gave Urizen a place in the north that was "obscure, shadowy, void, solitary" (*The Book of Urizen* 2:1–4, p. 69). For other explanations, see Gleckner ("*Thel* and the Bible," pp. 579–80) and esp. Damon (*William Blake*, p. 312), Harper ("Thomas Taylor and Blake's Drama of Persephone," p. 382), and Raine (*Blake and Tradition*, p. 100), who discuss Porphyry's work on Homer's Cave of the Nymphs and Thomas Taylor's translation and explanation of it. According to Porphyry and Taylor, unborn souls descend to generation through the northern gate of the Cave of the Nymphs. The only problem with applying this to the poem is that Thel seems to have descended at the beginning of it (1:1–5), and there are indications of her mortality prior to the passage under consideration (e.g., 3:21–23).

6:2. Similarly, in the translation of the *Inferno* (1785) that Blake owned, Dante described how, once past the entrance to hell, "wide before my wond'ring eyes were spread / The horrid secrets of the boundless deep" (*The Divine Comedy*, tr. Henry Boyd, 3 vols. [London: T. Cadell & W. Davies, 1802], 1:110).

6:2 (land unknown). Traditional metaphor for death, but this particular phrase appears in *NT* (e.g., 4. 148) and Wesley (e.g., 7:160).

6:3 (couches of the dead). Cf. Acts 5:15; Blake used *The Couch of Death* as a title in *PS*. For other explanations, see Gleckner ("*Thel* and the Bible," p. 580) and Harper ("Thomas Taylor . . . ," p. 383); the latter attributes Blake's source to Thomas Taylor himself, whereas it is actually Taylor's translation of the sixth book of the *Aeneid*.

6:3–4 (where . . . twists). This image seems to be a combination of a naturalistic description of the interior of a grotto, such as the one in Hervey's *Theron and Aspasio*, 2 vols. (London: Hamilton, Adams and Co., 1824), 1:339—"a sort of couch, composed of swelling moss, and small fibrous roots"—and the figure of the root of the tree that bears no good fruit in Matt. 3:10 and Luke 3:9. The latter was extremely popular with eighteenth-century religious writers, especially the evangelicals and Methodists, and was often used in connection with the heart and evil; e.g., "till the Heart is purified to the Bottom and has felt the Axe at the root of its evil" (William Law, *The Spirit of Love*, in *Works*, 9 vols. [London: G. Robinson, 1753–76], 8:176). Cf. also *NT* 4. 111–12, 9. 1395–96; Wesley 2:304, 352; and Hervey, p. 31. For other explanations, see Harper, "Thomas Taylor

...," p. 384; as with "couches of the dead" in n. 6:3, Blake's source is Taylor's translation of the *Aeneid*, bk. 6. Others, like Damon (*William Blake*, p. 312) and Tolley ("*The Book of Thel*," p. 384), suggest specific passages from Young and Hervey as sources.

6:5–7 (A . . . lamentations). A familiar scene in any number of works that Blake may have been acquainted with; e.g., *PL* 2. 614–19, in which Satan's bands viewed their "lamentable lot" and then passed through "many a dark and dreary vale" and "many a region dolorous."

6:6 (clouds). A prominent feature of the Valley of the Shadow of Death in *Pilgrim's Progress*; figuratively, darkness, as in the hells of *Paradise Lost* and the *Inferno*.

6:10. Reminiscent of the many unbidden complaints that Dante hears in his sojourn in hell (e.g., canto 7).

6:11–20. In *Los* 6:19–7:8 (pp. 67–68), this situation is blamed on the "privy admonishers of men," or representatives of the crown; see n. i:3–4.

6:13–14. Cf. Ps. 57:4 and Jer. 9:8. The connection of eyes with arrows and sieges is a common feature of religious and secular literature from the Elizabethan period onward. In secular poetry, love or lust conducts the siege (e.g., Ritson, *Select Collection of English Songs*, 1:11); in religious poetry God does it, intent on destorying sin (e.g., Wesley 2:350). Blake's use of the eyelids' arrows in connection with man's hostility seems to be unique.

6:17. Perhaps explained by *M* 5:23–24, 30–31 (p. 98), *J* 49:36–37 (p. 196), and *FZ* 55:24–26 (p. 330); i.e., because the ear has become a spiral, it draws in only "ordinary" sounds (like "Discord" and "Harmony") but not "pure" melodies, like those "struck by a hand divine." In Wesley (e.g., 4:393) *whirlpool* is used figuratively in connection with man's fallen nature and despair.

6:19–20. Deleted in copies III–1 and III–2 (see ill., p. 7). In both copies crumbs of the letters are visible, but in copy III–2 very small designs of birds have been drawn or painted in with brown ink.

6:20 (little curtain of flesh). I.e., the maidenhead. The god Hymen is usually depicted with a veil in one hand, as Blake could have learned from Bryant; cf. *J* 23:22 (p. 67), where by extension it becomes the "Veil of Moral Virtue." There is also an echo of Psyche's complaint to Cupid; see Irene H. Chayes, "The Presence of Cupid and Psyche," in *Blake's Visionary Forms Dramatic*, ed. David V. Erdman and John E. Grant (Princeton: Princeton University Press, 1970), pp. 214–43.

6:21 (shriek). Blake's usage of this word elsewhere is usually in connection with pain, grief, anguish, or a general fear; but his characters never shriek with fear in reaction to a particular threat (e.g., *The Little Girl Found*, l. 16, p. 21). In this case Thel seems to be horrified by the implications of the message above (6:11–20); see also above, p. 31.

Bibliography

FACSIMILE EDITIONS

1876 *Works by William Blake . . . Book of Thel, 1789 . . . Reproduced in Facsimile from the Original Editions.* [London]: private printing.

1884 *The Book of Thel.* London: Pearson. [William Muir's edition of copy II–5]

1893 *The Works of William Blake.* Vol. 3. Edited by Edwin John Ellis and William Butler Yeats. London: B. Quaritch.

1920 *The Book of Thel.* London: B. Quaritch. [William Muir's edition from a copy owned by Bernard Quaritch]

1924 ————. London: Frederick Hollyer. [edition of copy II–5]

1928 ————. London: V. Gollancz. [edition of copy II–5]

1967 ————. Clarivaux: Trianon Press. [edition of copy II–13]

SELECTED REFERENCES

ADLARD, JOHN. "Blake and Thomas Taylor." *English Studies* 44 (October 1963):353–54.

ALLIBONE, S. AUSTIN. *A Critical Dictionary of English Literature.* Vol. 1. Philadelphia: Childs and Peterson, 1859.

ANDERSON, QUENTIN. *The American Henry James.* New Brunswick: Rutgers University Press, 1957.

BEER, J. B. *Blake's Humanism.* Manchester: Manchester University Press, 1968.

BENOIT, FRANCOIS. *Un maître de l'art: Blake le visionnaire.* Lille: Au siège de l'Université, 1906.

BENTLEY, G. E., JR., and NURMI, MARTIN K. *A Blake Bibliography: Annotated Lists of Works, Studies, and Blakeana.* Minneapolis: University of Minnesota Press, 1964.

BERGER, PIERRE. *William Blake: Poet and Mystic.* Translated by Daniel H. Conner. 1914. Reprint. New York: Haskell House, 1968.

BINYON, LAURENCE. *The Drawings and Engravings of William Blake.* London: The Studio, 1922.

BLACKSTONE, BERNARD. *English Blake.* 1949. Reprint. Hamden, Conn.: Archon Books, 1966.

BLOOM, HAROLD. *Blake's Apocalypse: A Study in Poetic Argument.* Garden City, N.Y.: Doubleday & Co., 1963.

BLUNT, ANTHONY. *The Art of William Blake.* New York: Columbia University Press, 1959.

BOTTRALL, MARGARET. *The Divine Image: A Study of Blake's Interpretation of Christianity*. Rome: Edizioni di storia e letteratura, 1950.

BROOKE, STOPFORD. "William Blake." In *Studies in Poetry*. London: Duckworth & Co., 1907.

BULLOUGH, GEOFFREY. "*The Book of Thel*." In *Versdichtung der englischen Romantik: Interpretationen*, edited by Teut A. Riese and Dieter Riesner. Berlin: E. Schmidt, 1968.

BURDETT, OSBERT. *William Blake*. New York: The Macmillan Co., 1926.

CARY, ELISABETH LUTHER. *The Art of William Blake His: Sketch-Book; His Water-Colors; His Painted Books*. New York: Moffat, Yard & Co., 1907.

CASIER, ESTHER. "William Blake: A Study in Religious Sublimation." *Catholic World* 162 (1946):518–25.

CESTRE, CHARLES. *La révolution française et les poètes anglais (1789–1809)*. Dijon: Hachette & Cie., 1906.

COLLINS, MORTIMER. "William Blake, Seer and Painter." In *Pen Sketches by a Vanished Hand*. Vol. 2. London: R. Bentley & Son, 1879.

[CRAWFURD, OSWALD.] "William Blake: Artist, Poet, and Mystic." *New Quarterly Magazine* 2 (1874):466–501.

DAMON, S. FOSTER. *A Blake Dictionary: The Ideas and Symbols of William Blake*. Providence: Brown University Press, 1965.

————. *William Blake, His Philosophy and Symbols*. 1924. Reprint. Gloucester, Mass.: Peter Smith, 1958.

DAUGHERTY, JAMES H. *William Blake*. New York: Viking Press, 1960.

DE SELINCOURT, BASIL. *William Blake*. New York: Charles Scribner's Sons, 1909.

ELLIS, EDWIN JOHN. *The Poetical Works of William Blake*. London: Chatto and Windus, 1906.

————. *The Real Blake: A Portrait Biography*. London: Chatto and Windus, 1907.

————, and YEATS, WILLIAM BUTLER, eds. *The Works of William Blake: Poetic, Symbolic, and Critical*. Vol. 1. London: B. Quaritch, 1893.

ELTON, OLIVER. *A Survey of English Literature, 1780–1880*. Vol. 1. New York: The Macmillan Co., 1920.

ERDMAN, DAVID V. *Blake: Prophet against Empire*. 2d ed. rev. Princeton: Princeton University Press, 1969.

————, ed. *The Poetry and Prose of William Blake*. Garden City, N.Y.: Doubleday & Co., 1965.

[EVANS, E. P.] "William Blake, Painter and Poet." *Hours at Home* 11 (1870):55–65.

FAIRCHILD, HOXIE NEALE. *Religious Trends in English Poetry*. Vol. 3. New York: Columbia University Press, 1949.

FISHER, PETER FRANCIS. *The Valley of Vision: Blake as Prophet and Revolutionary*. Edited by Northrop Frye. Toronto: University of Toronto Press, 1961.

FRYE, NORTHROP. *Fearful Symmetry: A Story of William Blake*. Princeton: Princeton University Press, 1947.

GARDNER, CHARLES. *William Blake the Man*. London: J. M. Dent & Sons, 1919.

GARDNER, STANLEY. *Infinity on the Anvil: A Critical Study of Blake's Poetry*. Oxford: B. Blackwell, 1954.

GARNETT, RICHARD. *William Blake, Painter and Poet*. London: Seeley & Co., 1895.

GILCHRIST, ALEXANDER. *Life of William Blake*. Revised by Ruthven Todd. London: J. M. Dent & Sons, Everyman's Library, 1945.

GILL, FREDERICK. "Blake—The Poet of Shattered Mankind." *London Quarterly & Holborn Review* 164 (1939):185–99.

GLECKNER, ROBERT F. "Blake's *Thel* and the Bible." *Bulletin of the New York Public Library* 64 (1960):573–80.

————. *The Piper and the Bard: A Study of William Blake*. Detroit: Wayne State University Press, 1959.

GOWING, EMELIA AYLMER. "William Blake." *Belgravia* 77 (1892):357–77.

GRIERSON, HERBERT J. C. *A Critical History of English Poetry*. New York: Oxford University Press, 1946.

HAGSTRUM, JEAN H. *William Blake, Poet and Painter: An Introduction to the Illuminated Verse*. Chicago: University of Chicago Press, 1964.

HAMILTON, GAIL [Mary Abigail Dodge]. *Skirmishes and Sketches*. Boston: Ticknor & Fields, 1865.

HARPER, GEORGE MILLS. *The Neoplatonism of William Blake*. Chapel Hill: University of North Carolina Press, 1961.

————. "Thomas Taylor and Blake's Drama of Persephone." *Philological Quarterly* 34 (October):378–94.

HERFORD, C. H. "William Blake." *Hibbert Journal* 26 (1927):15–30.

HEWLETT, HENRY G. "Imperfect Genius: William Blake." *Contemporary Review* 28 (1876):756–84.

HIRSCH, E. D., JR. *Innocence and Experience*. New Haven: Yale University Press, 1964.

"The Inventions of William Blake, Painter and Poet." *London University Magazine* 2 (1830):318–23.

KEYNES, GEOFFREY. *A Bibliography of William Blake*. New York: The Grolier Club, 1921.

————. "Blake, Tulk, and Garth Wilkinson." *Library*, 4th ser., 26 (1945):190–92.

————, ed. *The Complete Writings of William Blake*. London: Oxford University Press, 1966.

————, ed. *The Letters of William Blake*. 2d ed. rev. Cambridge, Mass.: Harvard University Press, 1968.

————, and WOLF, EDWIN, 2nd. *William Blake's Illuminated Books: A Census*. New York: The Grolier Club, 1953.

LANGRIDGE, IRENE. *William Blake: A Study of His Life and Art Work*. London: G. Bell and Sons, 1904.

LISTER, RAYMOND. *William Blake*. London: G. Bell and Sons, 1968.

LOWNDES, WILLIAM THOMAS. *The Bibliographer's Manual of English Literature*. Vol. 1. London: H. G. Bohn, 1857.

MARGOLIOUTH, H. M. *William Blake*. London: Oxford University Press, 1951.

MATHEWS, GODFREY W. "William Blake." *Proceedings of the Literary and Philosophical Society of Liverpool* 68 (1926):71–96.

MISLAND, J. "W. Blake." in *Littérature anglaise et philosophie*. Dijon, 1893.

MOORE, T. STURGE. "William Blake, Poet and Painter." *Quarterly Review*. 208 (1908):24–53.

MULCHAHY, T. I. "William Blake, Poet and Painter." *Irish Monthly* 50 (1922):519–26.

MURRY, J. MIDDLETON. *William Blake*. London: Jonathan Cape, 1933.

NICOLL, ALLARDYCE. *William Blake and His Poetry*. London: G. G. Harrap, 1922.

OSTRIKER, ALICE. *Vision and Verse in William Blake*. Madison: University of Wisconsin Press, 1965.

PERRY, T. S. "William Blake." *Atlantic Monthly* 35 (1875):482–88.

PERUGINI, MARK E. "An Eighteenth Century Occult Magazine: and a Query as to William Blake." *Bibliophile* 2 (1908):86–89.

PLOWMAN, MAX. *An Introduction to the Study of Blake*. New York: E. P. Dutton & Co., 1927.

"The Poetry of William Blake." *Current Literature* 32 (1902):110–11.

RAINE, KATHLEEN. *Blake and Tradition*. Princeton: Princeton University Press, 1968.

————. "The Little Girl Lost and Found and the Lapsed Soul." In *The Divine Vision*. Edited by Vivian de Sola Pinto. London: V. Gollancz, 1957.

ROSSETTI, WILLIAM MICHAEL, ed. "Prefatory Memoir." In *Poetical Works of William Blake*. London: Aldine Editions, 1874.

SCHORER, MARK. *William Blake: The Politics of Vision.* Rev. ed. New York: Alfred A. Knopf, Inc., Vintage Books, 1959.

SHORT, ERNEST H. *Blake.* London: P. Allan & Co., 1925.

SITWELL, EDITH. *The Pleasures of Poetry.* Second ser. *The Romantic Revival.* London: Duckworth & Co., 1931.

SLOSS, D. J., and WALLIS, J. P. R. *The Prophetic Writings of William Blake.* Vol. 2. Oxford: Clarendon Press, 1926.

SMITH, W. "William Blake's *Book of Thel.*" *Notes and Queries* 52 (1875):449–50.

STORY, ALFRED T. "William Blake." *Temple Bar* 106 (1895):525–37.

———. *William Blake.* London: S. Sonnenschein & Co., 1893.

SWINBURNE, CHARLES ALGERNON. *William Blake: A Critical Essay.* London: J. C. Hotten, 1868.

TOLLEY, MICHAEL J. "*The Book of Thel* and *Night Thoughts.*" *Bulletin of the New York Public Library* 69 (1965):375–85.

WALLIS, J. P. R. "Blake." In *The Cambridge History of English Literature.* Vol. 11. Edited by A. W. Ward and A. R. Waller. Cambridge: At the University Press, 1932.

WICKSTEED, JOSEPH H. *Blake's Innocence and Experience.* New York: E. P. Dutton & Co., 1928.

[WILKINSON, JAMES JOHN GARTH, ed.] *Songs of Innocence and of Experience.* London: W. Pickering and W. Newberry, 1839.

WILSON, MONA. *The Life of William Blake.* London: Nonesuch Press, 1927.

WRIGHT, THOMAS. *The Life of William Blake.* 2 vols. Olney, Bucks: T. Wright, 1929.

Index